Images of America
Tennessee Centennial
Nashville 1897

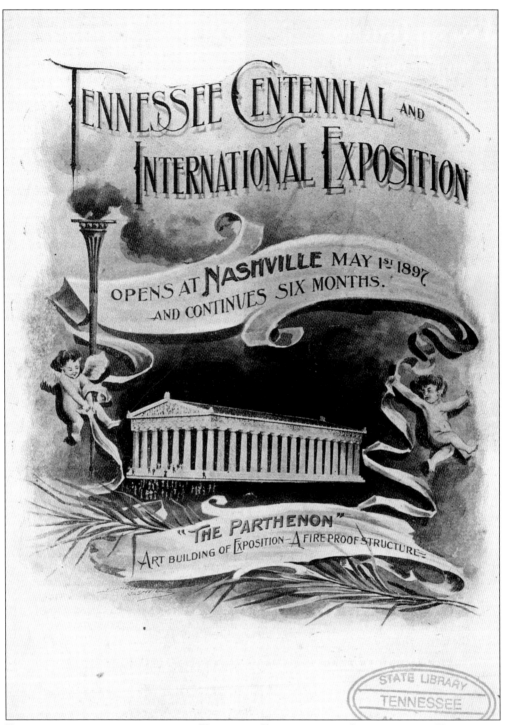

FRONT COVER OF A GUIDEBOOK TO THE TENNESSEE CENTENNIAL AND INTERNATIONAL EXPOSITION. The Exposition celebrated Tennessee's 100th year of statehood. It opened in Nashville on May 1, 1897, and continued on for six months, closing on October 30, 1897. (Courtesy of Tennessee State Library and Archives.)

IMAGES of America
TENNESSEE CENTENNIAL NASHVILLE 1897

Bobby Lawrence

ARCADIA
PUBLISHING

Copyright © 1998 by Bobby Lawrence.
ISBN 978-0-7385-6869-0

Published by Arcadia Publishing
Charleston SC, Chicago IL, Portsmouth NH, San Francisco CA

Printed in the United States of America

Library of Congress Catalog Card Number: 98-87449

For all general information contact Arcadia Publishing at:
Telephone 843-853-2070
Fax 843-853-0044
E-Mail sales@arcadiapublishing.com
For customer service and orders:
Toll-Free 1-888-313-2665

Visit us on the Internet at www.arcadiapublishing.com

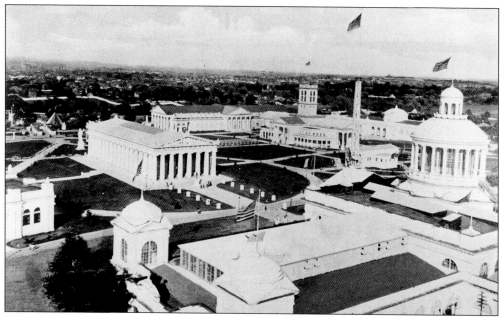

VIEW OF THE PARTHENON FROM THE TOP OF THE GIANT SEE-SAW. The structures are, from left to right, as follows: Education and Hygiene Building, the Parthenon, the Minerals and Forestry Building, the Auditorium, the U.S. Government Building, the History Building, and the Commerce Building (lower right). Beyond lie the trees of suburban West End and Vanderbilt University.

Contents

Acknowledgments 6

Introduction 7

1. Beginnings 9

2. People 23

3. Buildings 33

4. Vanity Fair 75

5. Special Days 95

ACKNOWLEDGMENTS

I want to thank the Lord for helping me to complete this work having been challenged with adversity on several occasions (Romans 8:28). I would like to express thanks to Chuck Sherrill and the staff at the Tennessee State Library and Archives, and Ken Fieth and the staff at the Metro Nashville Archives, Bo Adams, Peggy Dillard, Herb Peck Jr., Bettye Powers, Edwin P'Poole, Evelyn P'Poole, Nancy Merritt, Steve McFarland and Alan Doyle. Thanks to Monte Carroll and the wonderful staff at Chromatics Photo Imaging Services who helped with the copywork. Thanks to Dee Gee Lester who put me in contact with Arcadia; Sarah Maineri and the staff at Arcadia. A special thanks to Harriet Doerman who has been an inspiration to me with her wonderful stories. This book would not have been possible without the tireless efforts of my wife, Brenda, who helped me with the manuscript, and the understanding of my daughter, Amy, and my son, Jonathan, who gave up time with their Dad so he could work on this book.

This book is dedicated with love to Brenda, Amy, and Jonathan.

INTRODUCTION
The Tennessee Centennial Exposition

The "centennial idea" originated in the mind of a prominent Sumner County attorney named Douglas Anderson in the late summer of 1892. On the first Thursday in August 1892, Anderson picked up a backless copy of *Phelan's School History of Tennessee* while attending the regular county election in the flourishing city of Number One. He took it home and began reading the author's account of Tennessee's admission to the Union on June 1, 1796. The idea occurred to Anderson that Tennesseans should celebrate the 100th anniversary of that event. He wrote an article suggesting that this should be done and sent copies to the editors of various newspapers across the state. Anderson suggested that six cities, Knoxville, Chattanooga, Nashville, Columbia, Jackson, and Memphis, should vie for the privilege of staging the celebration. In Anderson's words, "Tennesseans should celebrate the occasion by holding a centennial exposition. They should do this because, being a patriotic people, they love and revere the memory of their brave ancestors who suffered privation, endured great hardships, and endangered their scalps for the great benefit of their descendants."

The idea was tossed about for a while by the press and social clubs. On January 1, 1894, Mr. George H. Armistead, former secretary of the Commercial Club of Nashville, became editor of the *Nashville American* newspaper. He wrote a series of articles urging that the Centennial Exposition be held. Nashvillians, who had successfully staged a city centennial in 1880, saw the financial advantages of holding an exposition and went to work.

Business organizations of the city held several private meetings. On July 8, 1895, the Nashville Chamber of Commerce met. After a stirring speech by chairman Tulley Brown, the members formally decided that Nashville would be the site of the celebration.

West Side Park was chosen as the place to celebrate Tennessee's 100th year of statehood. The park, a 200-acre site, was a former fairgrounds and harness racing park where visitors would come to watch the "trotters" run. West Side Park was situated about 2 miles from downtown Nashville and was easily accessible by electric streetcar, by rail, by carriage, and by foot to most visitors.

The racing park was renamed Centennial City and was incorporated. It had its own mayor, police force, hospital, council of aldermen, power plant, telephone service, and post office. The Exposition grounds included about 35 major structures, four lakes, military camps, restaurants, circus grounds, a photographic gallery, and an amusement section called Vanity Fair, which had rides and games that would rival the amusement parks of today. The Exposition's executive

committee used Chicago's Columbian Exposition of 1893 and Atlanta's Cotton States Exposition of 1895 as models in planning the designs and activities of the Tennessee celebration. In fact, many of the same side-show attractions were featured in all three.

The opening of the Exposition, which was originally to run from September through November 1896, was delayed because there was a lack of funding and the construction of the buildings was not complete. Formal celebrations were held June 1 through June 3, 1896, on the 100th anniversary of Tennessee statehood. The Exposition was opened to the world on May 1, 1897, and continued until October 30, 1897. During the six-month duration of the Exposition, hundreds of thousands of visitors passed through the gates, viewed the exhibits, enjoyed the food and fireworks, and wondered at the illusions and side shows. As Dr. Robert E. Corlew wrote in his book *Tennessee A Short History*, "The Exposition was truly Tennessee's greatest contribution to the gilded age."

Today, the Parthenon remains the only surviving structure from the Exposition in the park. Lake Watauga and Willow Island remain. Lily Lake survives as the Sunken Gardens. The iron wheels from Sycamore Powder Mill were left after the Exposition ended. A monument to the president of the Centennial, J.W. Thomas, was erected in 1906, a monument to the leaders of the Exposition in 1904, and a monument was erected to mark the site of the woman's building near the children's playground. Little else remains on the grounds to commemorate the Centennial; however, many untold stories remain tucked away in dusty old trunks and old family photo albums. Centennial Park, site of the 1897 Exposition, is today, Nashville's premier city park.

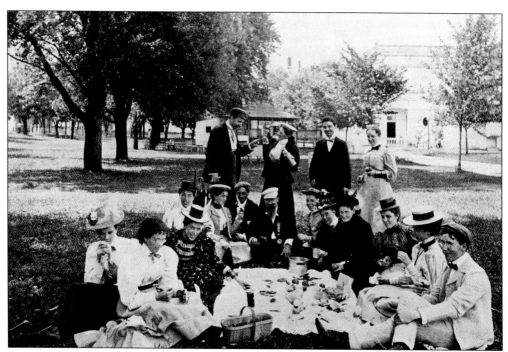

A PICNIC ON THE GROUNDS. Here is a familiar scene to all who ever spent the day at the Exposition. Under the cool shade of the trees, many families spread out the dinner they had brought on a blanket on the ground. It was not uncommon to look through the shaded areas of beautifully landscaped gardens and see 40 or 50 groups such as this creating pleasant memories.

One

BEGINNINGS

The beginning ideas for holding a state centennial celebration date back to the Nashville City Centennial in 1880. There was talk at that time of staging an extravaganza of grand proportions. Douglas Anderson reintroduced the idea in late summer of 1892. Excitement began to spread and Nashville was chosen as the site. Three years after the suggestion by Anderson, groundbreaking took place in the old West Side Park. Construction began almost immediately with the laying of the cornerstone of the Parthenon, the Nashville Building, in October 1895. Plans were made to celebrate Tennessee's 100th birthday in the fall of 1896. However, when the time came, buildings were incomplete and all of the funding was not in place. It was decided to postpone the opening for one year. On June 1, 1896, officials celebrated a three-day event which included speeches by the governor and other political leaders in the Auditorium, a parade through Nashville, and a "sham battle" in the Shelby Bottoms area of Edgefield. The official opening of the Exposition took place on May 1, 1897. Pres. William McKinley pressed a button in the White House in Washington, D.C. that started an electrical relay that ran down through Virginia, to North Carolina, across Tennessee, to Nashville that fired a cannon, setting the machinery into motion, and opening the gates to the Exposition.

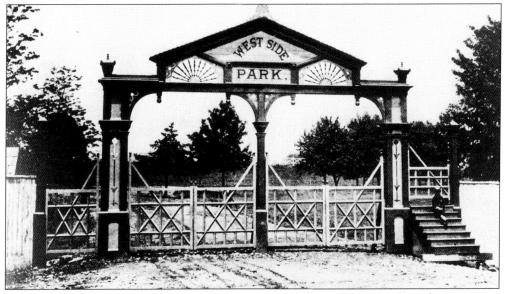

ENTRANCE TO THE WEST SIDE PARK. The site was the Old Fair Grounds, where the Tennessee Agricultural Association had sponsored fairs in 1879 and 1884. West Side Park opened in 1887 and sponsored harness racing through the fall season of 1892. This location on West End Avenue had seen troops mustered for the War of 1812, the Mexican War, and the Civil War. Horseracing moved to Cumberland Park in 1893. West Side Park was eventually the location chosen to hold the Tennessee Centennial Exposition. (Courtesy of Margaret Lindsley Warden.)

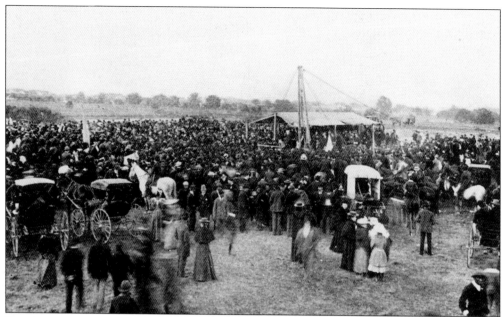

THE CEREMONIES SURROUNDING THE LAYING OF THE CORNERSTONE OF THE PARTHENON (THE NASHVILLE BUILDING) ON OCTOBER 8, 1895. The official groundbreaking began on September 10, 1895, to construct the building which would become known as the "Crown Jewel" of the Exposition.

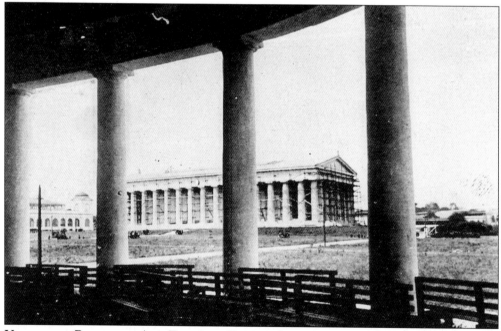

VIEW OF THE PARTHENON (THE FINE ARTS BUILDING) UNDER CONSTRUCTION. This photograph was taken from the porch of the Auditorium (note the scaffolding). The Parthenon had a stone foundation and brick interior walls, while the outside structure was made of wood. Plaster pediment sculptures adorned each end of the Parthenon. The roof was made of metal and was designed with a skylight.

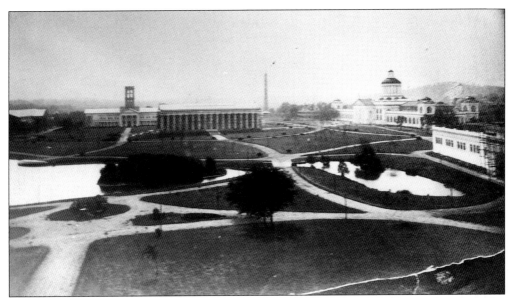

VIEW OF CENTENNIAL GROUNDS UNDER CONSTRUCTION. This photograph was taken from the Agriculture Building. The buildings, from left to right, are: the Minerals and Forestry Building, Auditorium, Parthenon, Commerce Building, and Transportation Building. Lake Watauga is to the left, and Lily Lake is situated to the right. The island in Lake Watauga would become the Blue Grotto. (Courtesy of TSLA.)

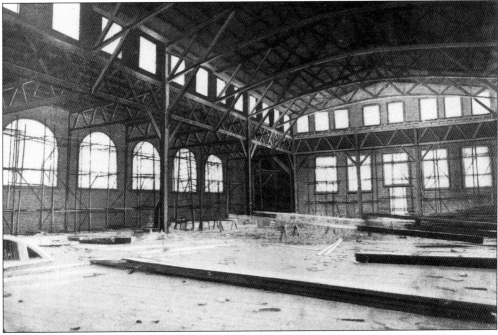

THE UNITED STATES GOVERNMENT BUILDING UNDER CONSTRUCTION. The outside dimensions were 150 by 350 feet, and the building afforded space for ten departments. It was a wooden structure covered with staff (material used on exterior wall coverings of temporary buildings) similar to the buildings of the World's Fair in Chicago in 1893. Congress appropriated $130,000 for the construction of the building and the design of the exhibits.

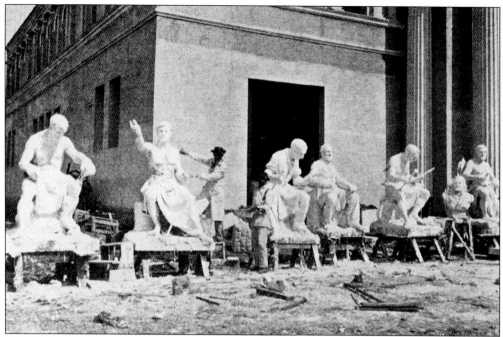

THE SCULPTING OF STATUARY IN FRONT OF THE TERMINAL BUILDING. Most of the statuary that graced the landscapes and structures of the Exposition were made from plaster. They were completed quickly and were done so with the intent of only lasting the six months of the fair. The majority of the buildings were destined to come down the following year.

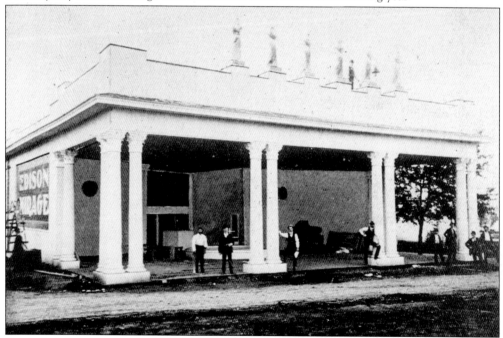

EDISON'S MIRAGE UNDER CONSTRUCTION. This site would become a favorite stopping place in Vanity Fair. The building would eventually house the Electric Scenic Theater, where one could view at least four different motion picture shows which lasted about 20 minutes each.

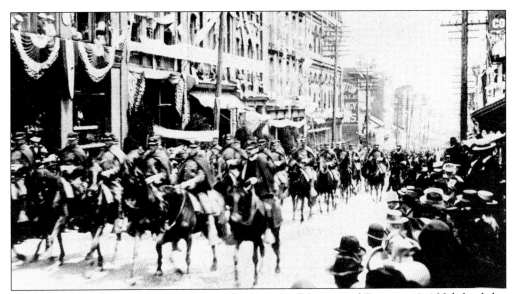

VIEW OF THE INAUGURAL DAY PARADE. The formal celebration of Tennessee's 100th birthday took place on June 1, 1896. The streets of the city thronged with a crowd that numbered 125,000. Ten thousand people were in line for the parade, some in carriages, others on horseback, while thousands were on foot. National and state troops, historical societies, fraternal and benevolent orders, and ladies in beautifully decorated carriages were notable features in the great procession that stretched for 8 long miles through the leading streets of the city.

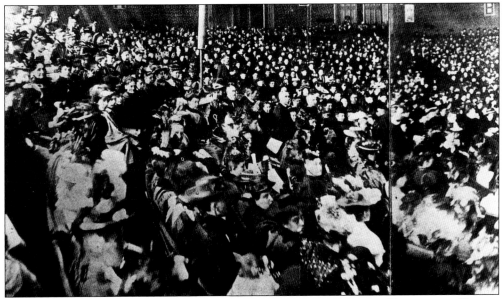

REVIVAL HELD BY BAPTIST EVANGELIST SAM JONES AT THE UNION GOSPEL TABERNACLE (RYMAN AUDITORIUM) IN OCTOBER 1896. Members of the Women's Christian Temperance Union were present as the alcohol question was addressed. Opposition was raised to the sale of alcohol on the Exposition grounds. The state legislature compromised. Centennial City was incorporated and was allowed to sell beer and wine but no hard liquor, even though Jack Daniel's had won the gold medal in Chicago four years earlier. (Courtesy of TSLA.)

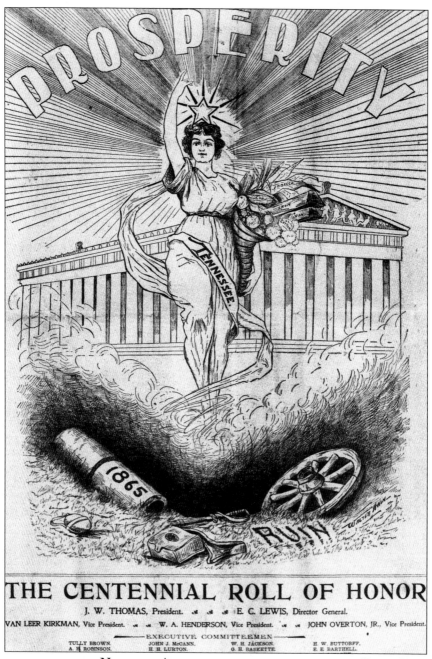

Special edition of the *Nashville American* newspaper illustrating "Lady Tennessee" rising up out of the ashes of the War Between the States and the Reconstruction Period, leading the New South into the next century. The Parthenon pictured in the background is symbolic of Nashville's role in the Exposition. (Courtesy of Metro Nashville Archives.)

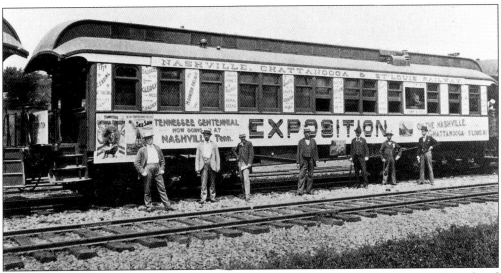

THE ADVERTISING CAR OF THE NASHVILLE, CHATTANOOGA, AND ST. LOUIS RAILWAY. The railroad was one of the primary sponsors of the Exposition. This decorated car traveled through the territory contiguous to Nashville and to Tennessee and advertised the Exposition in 1896–1897. The car attracted so much attention that all along its scheduled route, people would gather. Some traveled as far as 20 miles. The photograph shows Anthony Gorman of Gorman and Boone's Wild Animal Show and the force which accompanied him on his advertising tour.

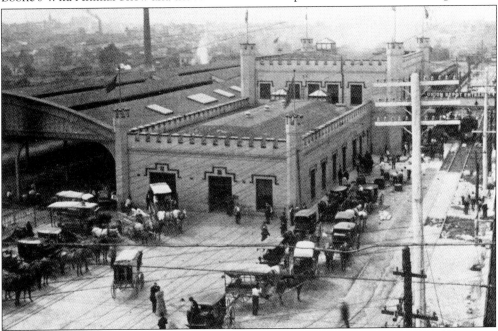

UNION STATION IN DOWNTOWN NASHVILLE. The railroad station, situated in the gulf between Broad Street and Church Street, was typically the place that first-time visitors to the "Rock City" would have a chance to experience. Wagons and carriages would line up to take curiosity seekers to their hotels or out to the Centennial grounds. At the height of the Exposition, during the Confederate Veterans Reunion, 55 to 60 trains per day brought in out-of-town guests.

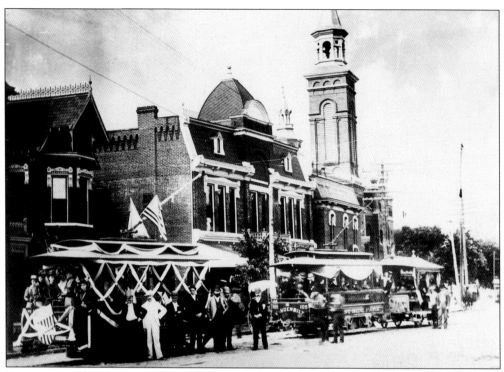

STREETCARS. These streetcars ferried passengers from the downtown hotels and all parts of the city to the Centennial grounds for a fare of 5¢. The Nashville Street Railway Company ran cars to two different stations at the Exposition. Nashville had been operating electric cars since 1889, as shown in this photograph (note the West Side Park car on the right). (Courtesy of TSLA.)

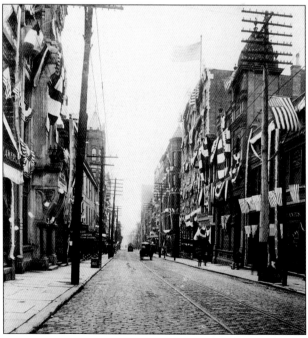

COLLEGE STREET (THIRD AVENUE), DOWNTOWN NASHVILLE, OPENING DAY, TENNESSEE CENTENNIAL EXPOSITION, MAY 1, 1897. Opening Day was overcast in the early morning with a cool mist in the air; however, by 11 a.m., when J.W. Thomas, president of the Centennial, declared the Exposition "open to the world" in the opening ceremonies, the sun was shining, and the celebration opened with great promise. The pride of the Nashville people can be seen in the display of flags and bunting. (Courtesy of TSLA.)

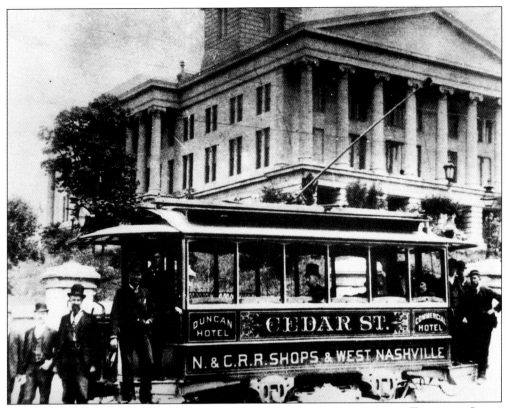

PASSENGERS AND CONDUCTORS ON AN ELECTRIC STREETCAR IN FRONT OF THE TENNESSEE STATE CAPITAL BUILDING ON CEDAR STREET (CHARLOTTE AVENUE). This car ran between the Duncan Hotel and the Commercial Hotel to the railroad station and on to the Centennial grounds. (Courtesy of TSLA.)

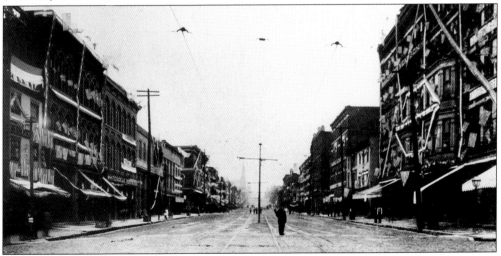

BROAD STREET LOOKING WEST FROM MARKET STREET (SECOND AVENUE) ON OPENING DAY OF THE TENNESSEE CENTENNIAL EXPOSITION, MAY 1, 1897. Parade routes usually started near this point and proceeded down Broad Street to West End Avenue, then to Capital Avenue, and ended on the Exposition grounds. (Courtesy of TSLA.)

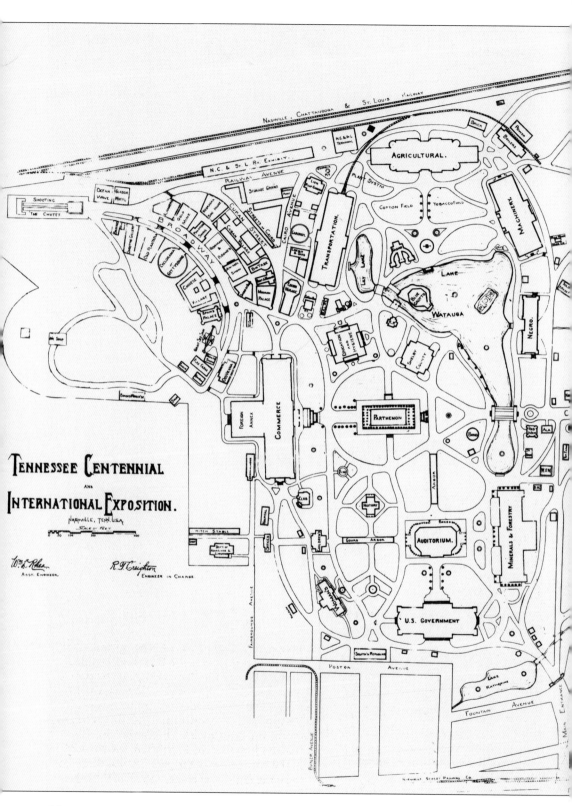

Map of the Exposition grounds. Fairgoers arrived by streetcar at the West End Terminal (lower right) or the Plunket Avenue Station off of Cedar Street (upper right). Military camps were set up in a 55-acre area (right center). Vanity Fair, the amusement section, was located on the hill (upper left). The Parthenon, the "Crown Jewel" of the Exposition, was situated in the very center of the park and was designed to be the fair's focal point with all of the other structures surrounding it.

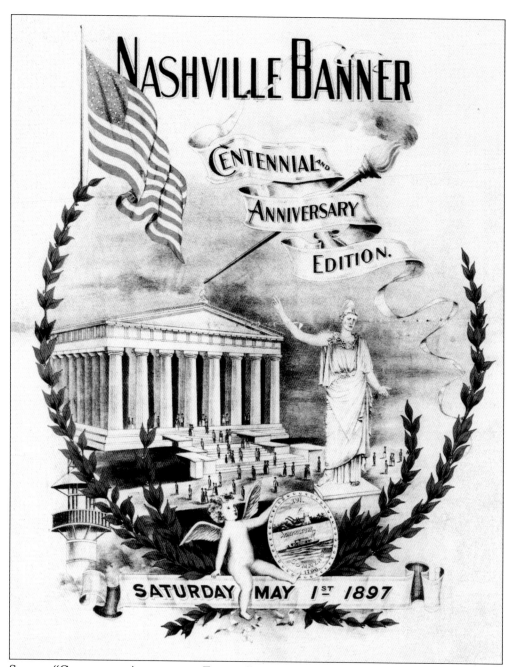

Special "Centennial Anniversary Edition" of the Nashville Banner newspaper, May 1, 1897. The Parthenon is shown here with the towering 40-foot statue of Pallas Athena on its front lawn. (Courtesy of Ken Fieth and Metro Nashville Archives.)

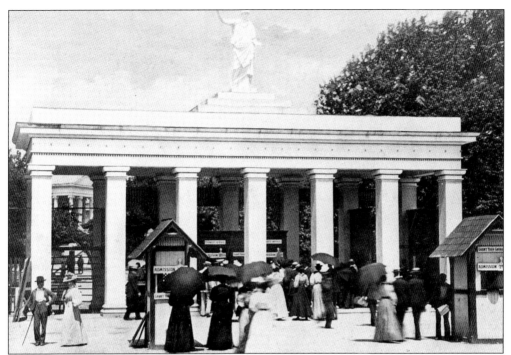

THE MAIN ENTRANCE. Located adjacent to Lake Katherine and near the terminal station of the Nashville Street Railway Company, the turnstiles of the main entrance permitted Exposition visitors to pass through the gates to the wonders that lay beyond. Admission prices were 50¢ for adults and 25¢ for children. Prices were cut in half after 7 p.m.

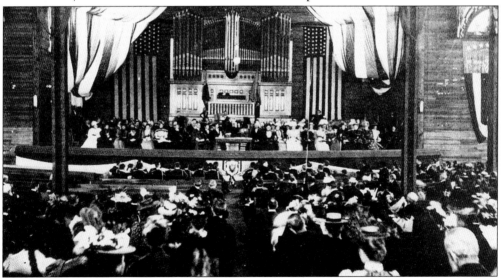

EXERCISES IN THE AUDITORIUM ON OPENING DAY. On the platform are seated, from left to right: Gov. Robert Love Taylor; the Hon. Adlai E. Stevenson, former vice president of the United States; Maj. J.W. Thomas, president of the Tennessee Centennial; Maj. E.C. Lewis, director general of the Exposition; and chiefs of the departments and other officials. The Bellstedt and Ballenberg Band was seated in the orchestra pit and played patriotic airs as the crowd cheered and applauded until exercises began at 11 a.m.

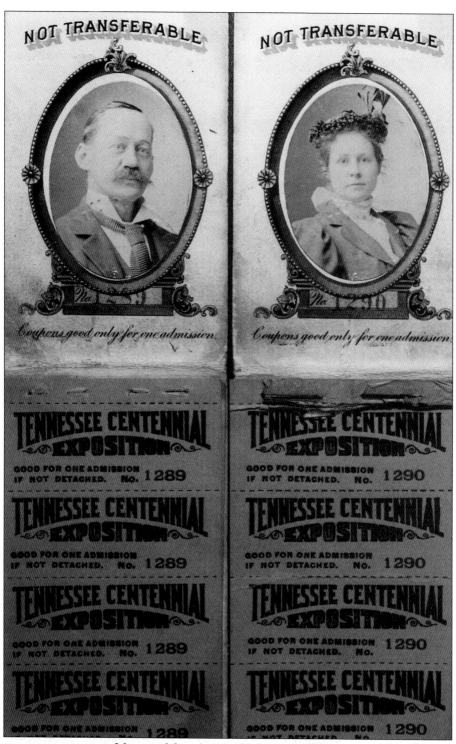

Season passes issued to Mr. and Mrs. Austin H. Merrill. Fairgoers could purchase season passes with photographs of the passholders and detachable tickets, or they could pay admission fees at the gate. (Courtesy of TSLA.)

Two

PEOPLE

The people who participated in the Tennessee Centennial Exposition represented a good cross-section of Tennessee's citizens. There were rich and poor. One young man from Chattanooga ran away from home with enough train fare to make it to Nashville but not enough to get back home. There were businessmen and politicians; there were ordinary citizens and countryfolk. There were former slaves and former slavemasters. There were former Confederate soldiers and former Union soldiers, all Tennesseans, who celebrated side by side, having shared the common experience of war.

Only 30 years had passed since the end of the War Between the States. Tennesseans, with their history of volunteering, had volunteered to lead their state out of the ashes of civil war and reconstruction into the new century. The citizens of the state wanted to show themselves as leaders in the "New South," with progress in agriculture, commerce, industry, and education.

Descendants' groups were represented, such as the Crockett Clan, the Sons of the American Revolution and Daughters of the American Revolution, the Sons of Confederate Veterans, and the Daughters of the Confederacy. Many veterans' groups held reunions, such as the United Confederate Veterans, Mexican War Veterans, and veterans of the Grand Army of the Republic. Black organizations were well represented at the Centennial in contrast to the expositions held in Chicago in 1893 and Atlanta in 1895. The Knights Templar Grand Commandery, the Grand Lodge African Free (A.F.) and Accepted Masons (A.M.), the colored Education Association, and the National Association of Colored Women were but a few of the black organizations that took part in the Tennessee Centennial Exposition.

Tennesseans took part in the celebration because they felt a patriotic spirit about who they were. The celebration reflected pride in their heritage and the future of their state.

NICHOLS FAMILY ON THE STEPS OF THE EAST ENTRANCE TO THE PARTHENON. Families often dressed in their fanciest attire for a day at the Exposition. (Courtesy of TSLA.)

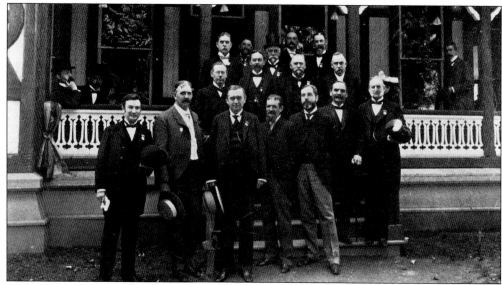

MEMBERS OF THE EXECUTIVE COMMITTEE ON THE STEPS OF THE ADMINISTRATION BUILDING. Posing on the steps are Van Leer Kirkman, first vice president (front row, second from left); J.W. Thomas, president (front row, third from left); and E.C. Lewis, director general (front row, fourth from left).

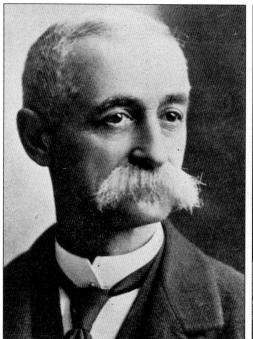 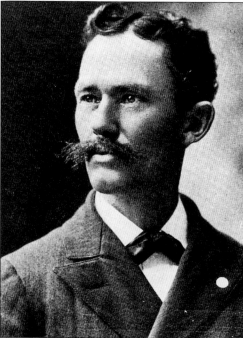

Left: MAJ. WILBUR FISK FOSTER, DIRECTOR OF WORKS AND FORMER CIVIL ENGINEER IN THE ARMY OF TENNESSEE, CONFEDERATE STATES OF AMERICA. Major Foster volunteered, along with several other civic leaders, to serve without compensation, demonstrating the patriotic spirit of the undertaking. *Right:* R.T. CREIGHTON, ENGINEER IN CHIEF. Mr. Creighton directed the construction of many of the Exposition buildings. R.T. Creighton's son would oversee the 1920s reconstruction of the Parthenon.

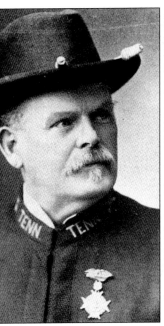 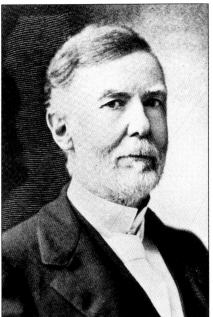 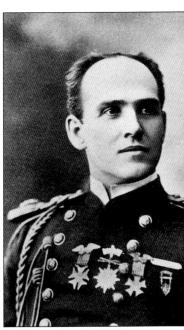

Left: **Col. William C. Smith, architect of the Parthenon.** Colonel Smith also drew the plans for the Robertson County Courthouse in Springfield, Tennessee and is credited with organizing the Tennessee National Guard. He died in the Philippines at the head of the First Tennessee Regiment during the Spanish-American War in 1898. *Center:* **Norman Farrel, mayor of Centennial City.** The 200-acre site of the Exposition was incorporated with its own mayor, board of alderman, police force, hospital, post office, and fire department. Its charter ended January 1, 1898. *Right:* **Col. Eastman G. Curry, commandant of the Centennial Guards.** The guards did an excellent job of maintaining order. The only serious incident took place in May, when a drunken contingent (75 to 100) of the Louisville Legion attempted to take charge of Vanity Fair but were stopped by the guards.

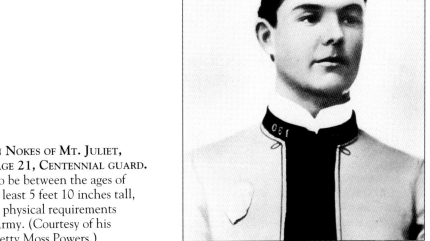

Noel Brown Nokes of Mt. Juliet, Tennessee, age 21, Centennial guard. Guards had to be between the ages of 21 and 35, at least 5 feet 10 inches tall, and meet the physical requirements of the U.S. Army. (Courtesy of his niece, Mrs. Betty Moss Powers.)

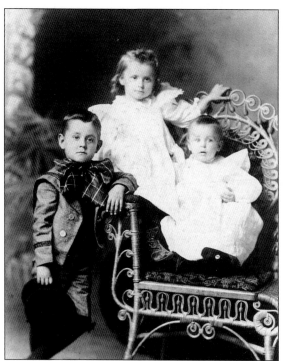

From left to right, James Ore Davis (age 5), Myrtle Allen Davis (age 3), and Rachel Elise Davis (age 1) of Hillsboro, Williamson County, Tennessee (Leipers Fork). This photograph was taken by Thuss Photographic Studio at the Exposition, October 1897. (Courtesy of Nancy S. Merritt.)

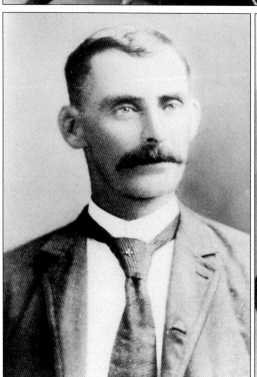
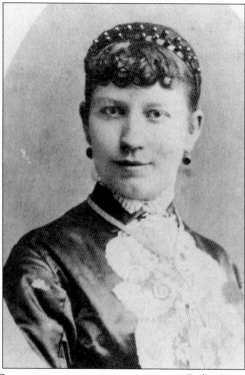

Left: Henry Hunter Davis, father of the Davis children pictured above. *Right:* Leer Tartan Davis, mother of the Davis children pictured above. (Photographs courtesy of Nancy S. Merritt.)

MISS ALICE BRINE, NEWSPAPER CORRESPONDENT. Newspaper coverage of the daily activities of the Centennial reached not only Tennessee communities but major cities across the United States, Western Europe, and Central and South America.

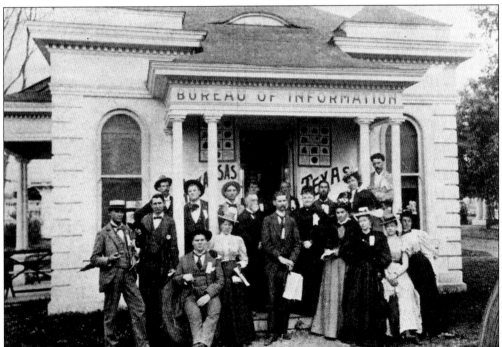

REPRESENTATIVES OF THE COTTON BELT LINE RAILWAY. These individuals stand ready and prepared to escort visitors to their headquarters building. The railroad industry was one of the primary supporters of the Exposition.

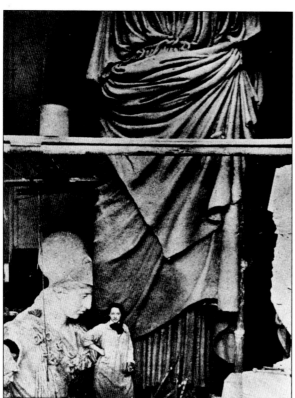

MISS ENID YANDELL, SCULPTOR OF THE PALLAS ATHENA STATUE, IN HER STUDIO IN PARIS, FRANCE. The statue was made of plaster and was reported to be the largest statue ever sculpted by a woman.

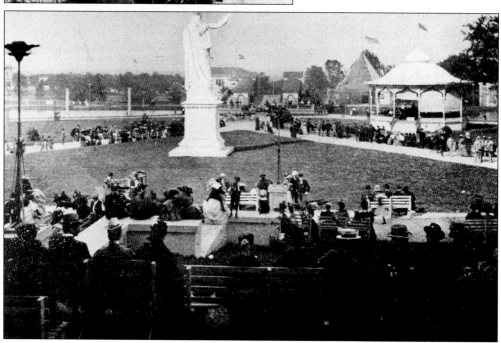

CROWDS ON THE LAWN AND THE STEPS OF THE EAST ENTRANCE TO THE PARTHENON FOR AN AFTERNOON CONCERT. Forty-foot-tall Pallas Athena graces the grounds and greets visitors to the Fine Arts Building.

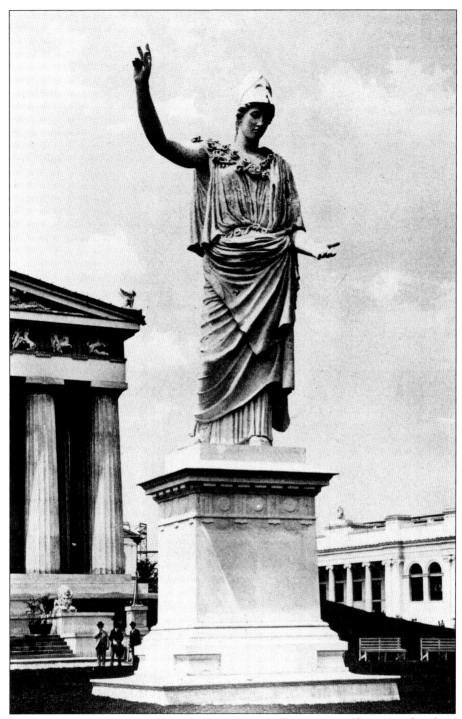

PALLAS ATHENA STATUE AT THE EAST ENTRANCE TO THE PARTHENON. She was sculpted in Paris, then shipped by rail to Amsterdam in three sections. Athena was then tied onto the deck of a steamship, sent to New Orleans, and shipped by rail to Nashville.

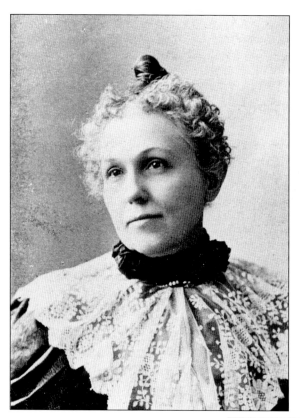

ANNIE SOMERS GILCHRIST, NOVELIST, POET, AND MEMBER OF THE D.A.R. Mrs. Gilchrist authored a book of poetry entitled *Centennial Souvenir*, which honored the patriotic heroes and heroines of Tennessee. Mrs. Gilchrist and the D.A.R. played a prominent role in celebrating Tennessee's 100th year of statehood.

ANNIE GILCHRIST, JOHN GILCHRIST, AND ETHEL GILCHRIST, CHILDREN OF THE AMERICAN REVOLUTION. Children also played an important role in honoring the brave men and women of Tennessee.

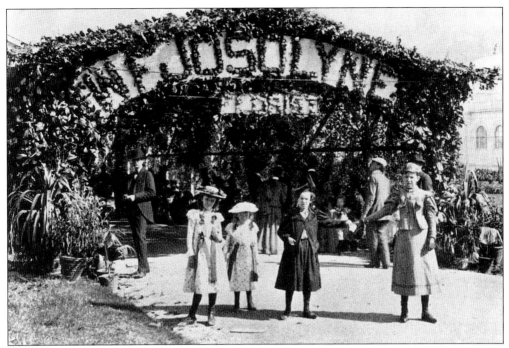

A GROUP OF CHILDREN LEAVING THE COOL SHADE OF THE VINE ARBOR WHICH LED TO THE ENTRANCE OF THE AUDITORIUM.

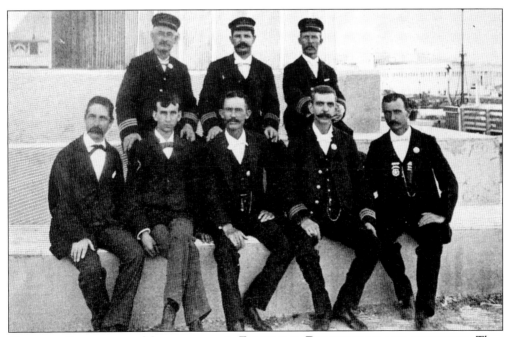

CHIEFS OF ENGINEERING, MACHINERY, AND ELECTRICAL DEPARTMENTS AND ASSISTANTS. They are seated on the steps at the east entrance to the Parthenon.

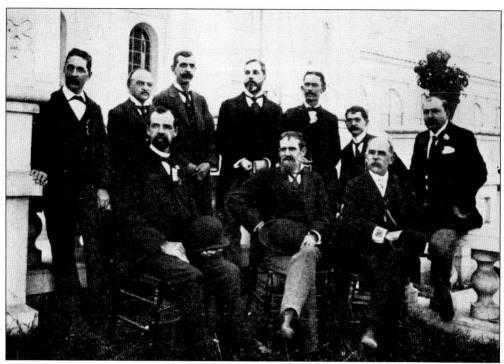

Major Eugene Castner Lewis, director general of the Exposition, and his staff.

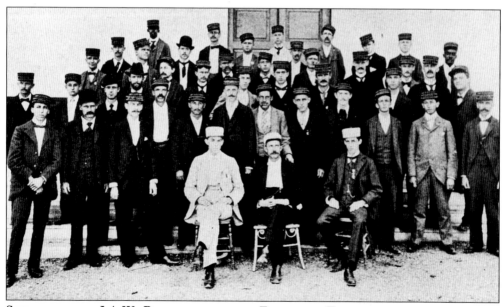

Superintendent J.A.W. Pentecost and the Electrical Force seated in front of the Machinery Building. The Department of Electricity generated power for over 18,000 incandescent lamps, 458 arc lights, and numerous pieces of machinery.

Three

BUILDINGS

The buildings! The buildings were magnificent, awe inspiring, and breathtaking, and they were filled with all sorts of curiosities, historical artifacts, artwork, sculpture, and displays, so numerous that it would boggle the mind of the average person. The official guidebook to the Exposition explained that it would take six days to see the entire grounds. Classical-style architecture was used in designing many of the structures. There were Greek, Roman, Egyptian, Spanish, Colonial, and other types of buildings represented on the grounds. The exhibit halls were erected hastily, the entire lot being constructed in less than 16 months. The builders of the structures were more concerned with the appearance of the outsides of their edifices than the insides. Therefore, the outer walls were adorned with statuary, flags, and elaborately decorated entranceways. The walls of the Memphis Pyramid and the Streets of Cairo were even painted with hieroglyphics.

The interiors of the main structures resembled huge open warehouses. The Victorian art of utilizing space was employed. There were as many objects on display as would fit inside an exhibit case. The paintings in the Parthenon were hung from floor to ceiling, using every conceivable inch of space. Potted plants, benches, and chairs were strategically placed throughout the exhibit halls. Restaurants were to be found inside several buildings such as the Roof Garden in the Woman's Building and the Watauga Cafe in the Negro Building. The buildings were equipped with electricity, restroom facilities, and the Machinery Hall even had air conditioning, while many others were equipped with electric fans.

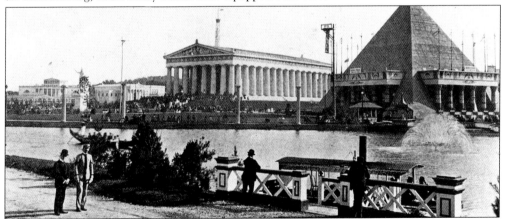

VIEW OF THE PARTHENON ACROSS LAKE WATAUGA WITH UNIFORMED CENTENNIAL GUARD STANDING (LOWER LEFT) IN FOREGROUND. The steamboat, *Huck Finn*, is docked on the east bank of the lake. A Venetian gondola is ferrying passengers across the lake. To the right of the Parthenon is the Memphis-Shelby County Building, based on the Pyramid of the Cheops in Ancient Egypt. The structures, from left to right are: the Woman's Building, the Pallas Athena Statue, the History Building, and the great flag staff (behind the Parthenon). Atop the two tall platform poles on the west bank of the lake, Arion performed his acrobatic high-wire act.

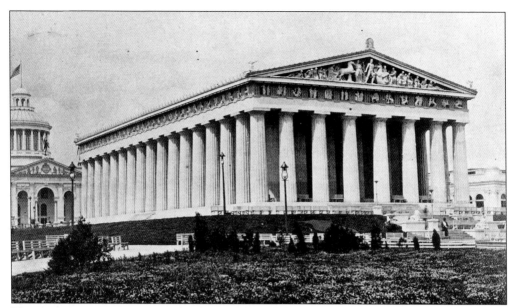

VIEW OF THE EAST ENTRANCE TO THE PARTHENON. The Parthenon was the Nashville-Davidson County building. The decision was made to build the Parthenon because of Nashville's nickname "The Athens of the South." It housed nearly 1,200 pieces of artwork and sculpture from all over the world. The Parthenon was situated in the center of the Exposition grounds because of Nashvillians' pride in their city.

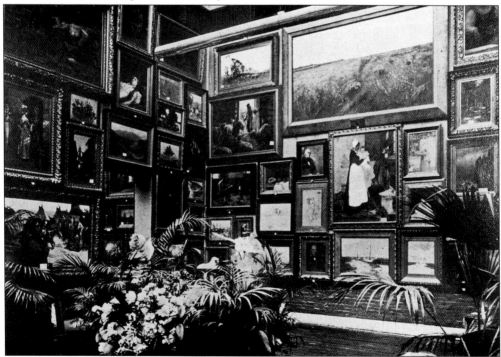

THE PARTHENON INTERIOR. The Fine Arts Department displayed their artwork in salon style which was the Victorian way of using every inch of space possible. Palms and flowers are set about to make the galleries more pleasing to visit.

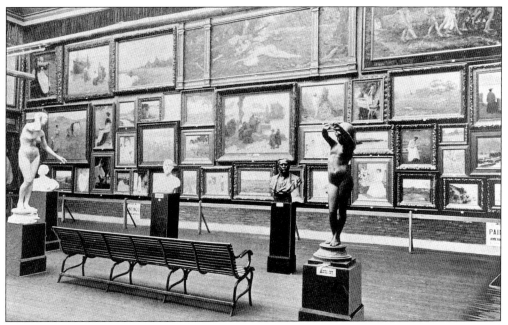

THE PARTHENON INTERIOR, THE AMERICAN ARTISTS SECTION. Benches were strategically placed so that visitors could sit and enjoy the artwork and sculpture. The bust of the Centennial's president, J.W. Thomas, sits in the foreground while paintings such as *The Garden of Persephone* (upper right) adorn the walls.

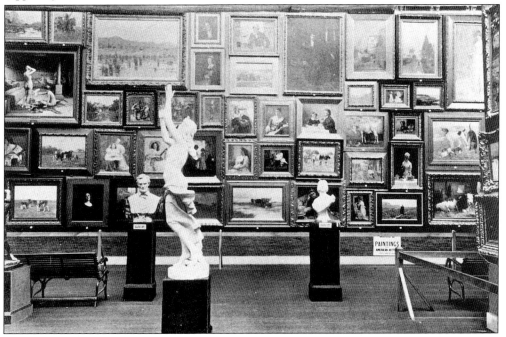

THE PARTHENON INTERIOR, THE AMERICAN ARTISTS SECTION. There is a bust of Abraham Lincoln in the foreground and paintings such as *The Bath* (upper left) and J.V. Longman's *Prayer for Daily Bread* (center). Artwork on display was chosen by a committee headed by Theodore Cooley, chief of the Fine Arts Department.

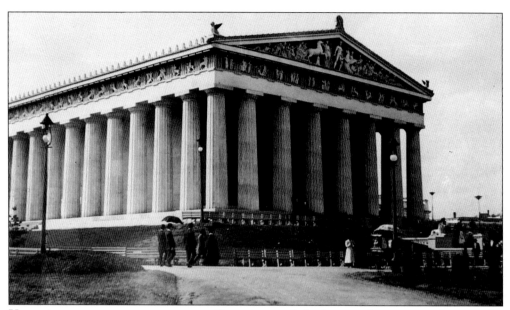

VIEW OF THE EAST ENTRANCE TO THE PARTHENON. A fresh roasted peanut vendor provides refreshments to fairgoers at the base of the steps. The pediment sculptures seen just beneath the roofline depict the contest between Poseidon and Athena. The west pediment sculptures of the ancient Parthenon were reproduced by sculptor George Zolnay at both ends of the Nashville Parthenon and were made of plaster.

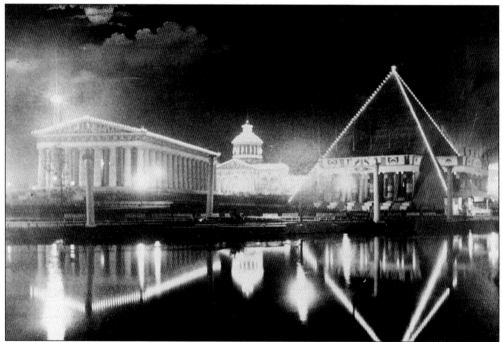

ELECTRIC EFFECTS BY MOONLIGHT. Looking across the lake, the visitor sees the Parthenon and the Memphis Building, both illuminated by the electric lights, while back beyond, the Commerce Building fills in the center of the picture. The reflection in the lake water shows the strange and weirdly beautiful scenes that greeted the people who walked along the lakeside at night.

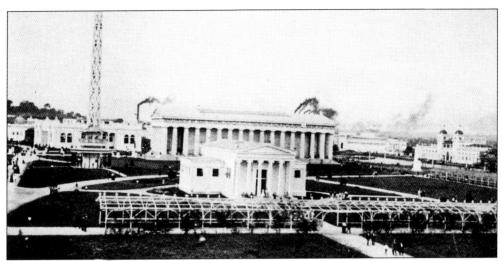

THE HISTORY BUILDING. This building (center), modeled after the Erectheon in ancient Athens, was under the direction of Gen. G.P. Thruston. The architect was Col. W.C. Smith. The History Building housed exhibits which included one by the Tennessee Historical Society, a Confederate exhibit, an exhibit by the Colonial Dames and the D.A.R., the Jackson Collection, and many others.

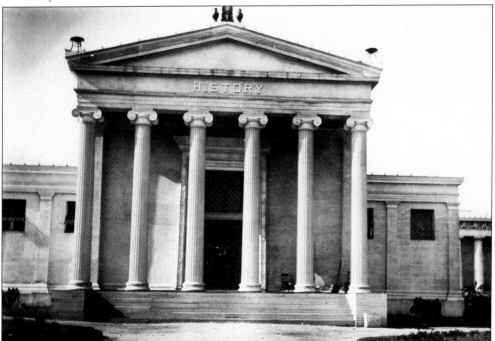

THE HISTORY BUILDING'S FRONT ENTRANCE. Many relics of Tennessee history were put on display for the public. The Ladies' Hermitage Association had an exhibit in the south wing. The Confederate Memorial Association had on display battle flags and regimental flags, the sword, pistol, and sash of General Forrest, the pistol of General Hatton, the spurs worn by General Cheatham, and busts and portraits of many confederate leaders. The D.A.R. section displayed heirlooms and relics of the old pioneer families of the state, including those of the Seviers, the Campbells, the Robertsons, and the Polks. (Courtesy of TSLA.)

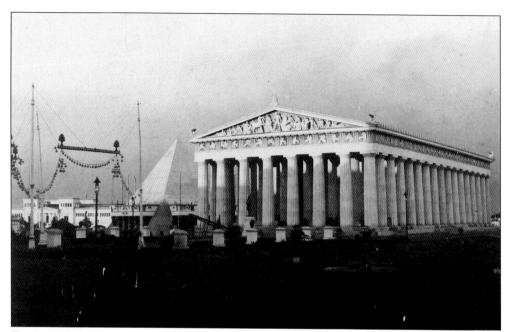

THE WEST ENTRANCE TO THE PARTHENON AT SUNSET. The Moretti statue of Vanderbilt is located near the entrance. The Memphis pyramid is situated to the Parthenon's left. (Courtesy of Peggy Dillard.)

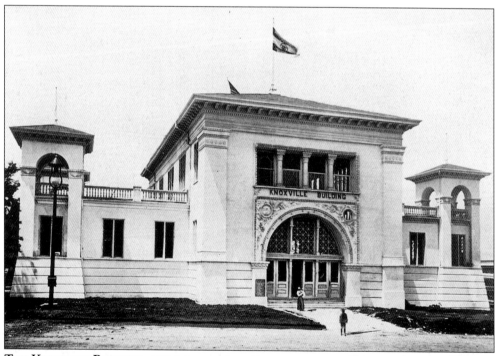

THE KNOXVILLE BUILDING, THE LARGEST OF ALL STRUCTURES ON CAPITAL AVENUE. The city of Knoxville took up the work of commemorating the past and present achievements of east Tennessee. The building was filled with the products of Knoxville industry.

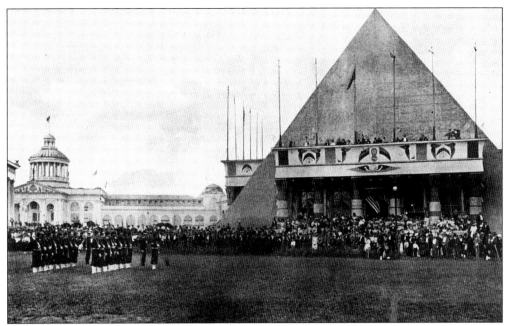

THE MEMPHIS-SHELBY COUNTY BUILDING. This structure was modeled after the Cheops Pyramid because of the city of Memphis and its connection to ancient Memphis, Egypt. The crowd gathered on the steps of the pyramid is watching the drill performed by the Nelly Saunas on "Memphis Day." Inside the pyramid were displays sponsored by the businesses of Memphis exhibiting commerce and industry.

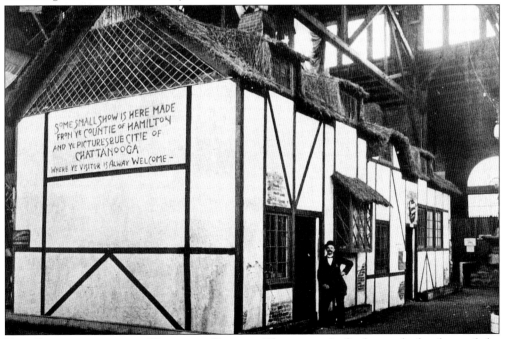

THE CHATTANOOGA AND HAMILTON COUNTY. This county's display took the form of the Ann Hathaway Cottage. This exhibit was housed in the south end of the Minerals and Forestry Building.

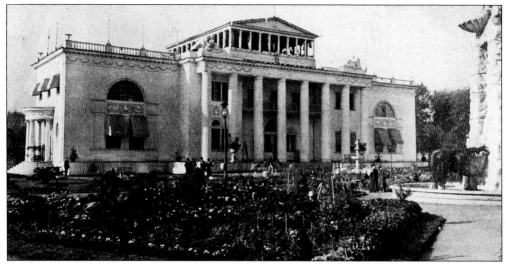

THE WOMAN'S BUILDING. The structure was designed by Mrs. Sarah Ward-Conley, after the Hermitage, the home of Pres. Andrew Jackson, and is of the old Colonial style of architecture. It was complete with an open-air restaurant at the top, a gift shop, flower gardens, fountains, paintings, sculptures, and a grand staircase, among many other things. Rooms were beautifully decorated with drapes, antique furniture, glassware, and artwork that reflected the styles of the day. Subjects exhibited included inventions, patents, books, artworks, and a host of other items all created by women. The "woman" was celebrated here, and the site was also the location of many elaborate dinners and receptions, including one honoring Mrs. William McKinley.

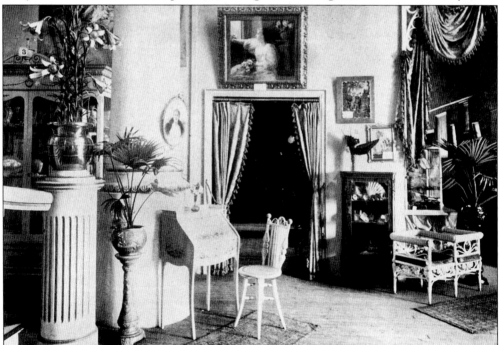

ENTRANCE TO THE WOMAN'S LIBRARY. This was one of the prettiest spots in the Woman's Building; the corner and the entrance to the library offered a great deal in small space. Above the door leading to the library hangs Mrs. Sarah Ward-Conley's masterpiece, *A June Rose*.

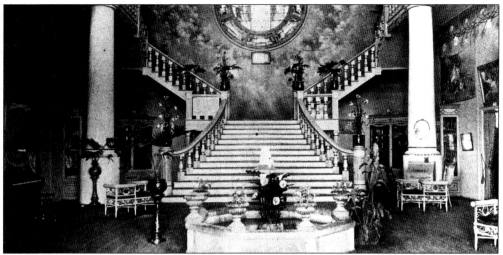

THE MAIN HALL, WOMAN'S BUILDING. It was the interior of this structure that attracted visitors. Entering at the front, we have this view of the beautiful main hall, which was decorated by the women of Memphis and Shelby County. The grand columns, the broad stairway leading to the second floor with its wide landing placed halfway up where the stairway divides, the splendid stained-glass window representing the "Apotheosis of Woman," the magnificent frieze of lotus vines and flowers, and the rich furnishings are all shown.

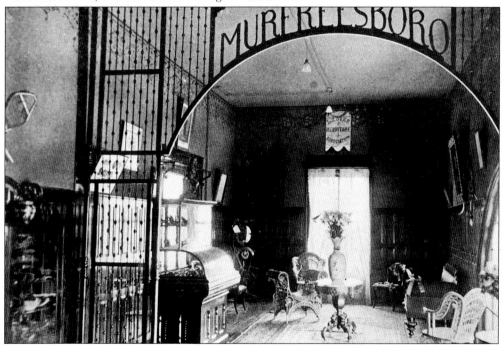

THE RED CEDAR ROOMS. Murfreesboro and Rutherford County women had an original idea for decorating these rooms. They fitted out these two rooms in the beautiful red cedar of Tennessee and separated them by a grill-work design containing the word "Murfreesboro," as seen in this picture. W.B. Earthman contributed the cedar, and Mrs. G.M. Darrow was the woman who saw after the details of the work. The rooms were filled with articles belonging to the Ladies' Hermitage Association.

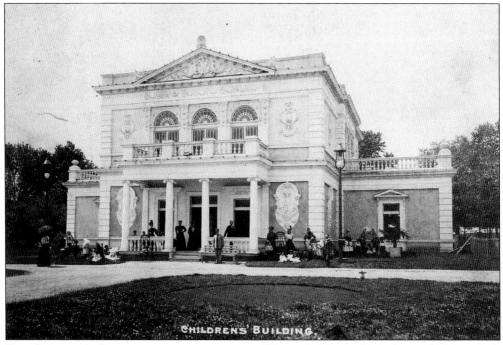

THE CHILDREN'S BUILDING, LOCATED NEAR THE WOMAN'S BUILDING. It featured playgrounds on the outside of the building as well as on the inside. To the right can be seen the corner of a fence that enclosed the deer petting zoo. (Courtesy of Edwin and Evelyn P'Poole.)

THE ELECTRIC FOUNTAIN. This site was a favorite place to gather in the evening. The fountain, created by sculptor Moretti, was powered by electricity and was lit at night. It was located near the entrance to the Woman's Building. (Courtesy of TSLA.)

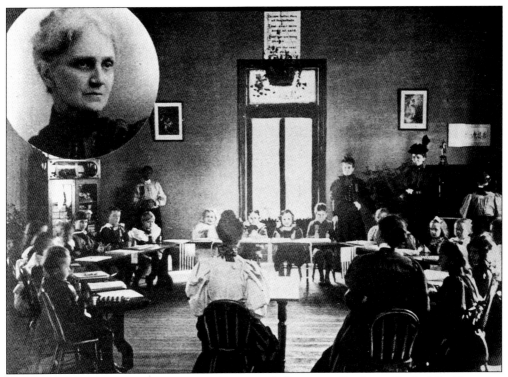

THE MODEL KINDERGARTEN, INSIDE THE CHILDREN'S BUILDING. Professor Davis, Miss Duncain, and Mrs. McHenry taught the kindergarten in which classes were held throughout the six months of the Exposition.

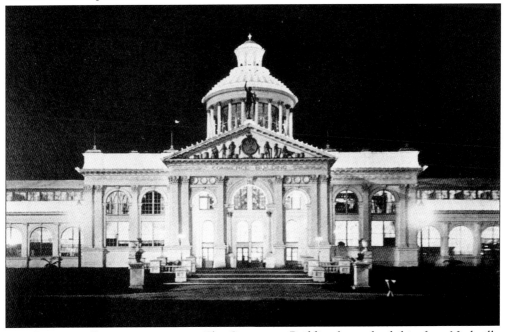

THE COMMERCE BUILDING AT NIGHT. The Commerce Building housed exhibits from Nashville businesses as well as exhibits from countries all over the world.

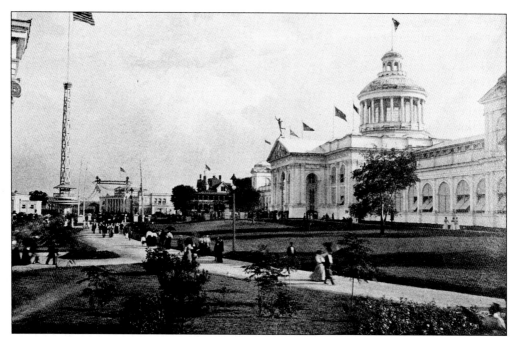

THE COMMERCE BUILDING. The people on this part of the grounds are on their way to see the President and are rushing along the broad road. Notice the arches in the distance. The arches were brought from Paris, and upon them were hung transparent celluloid lanterns. On the right are stretched out the Commerce Building, the West Side Club, and the Woman's Building. The 22-foot-tall statue of Mercury stands atop the main entrance. One wing of the History Building is just visible.

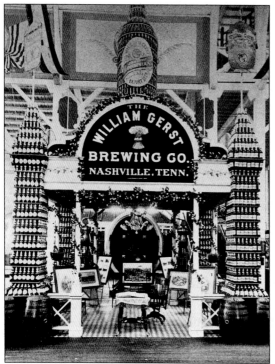

WILLIAM GERST BREWING COMPANY DISPLAY. The photograph to the right is a display which drew the attention of all the people. It was put together by an enterprising Nashville industry. The beautiful pavilion, with its innumerable bottles and columns constructed of bottles of beer, the great cask in the rear of the pavilion, and the general attractiveness of the exhibit made it conspicuous in the multitude of beautiful displays. The great vat in the rear had a capacity of 2,500 gallons.

THE B.H. STIEF JEWELRY COMPANY DISPLAY. Entering at the east door of the Commerce Building, the first exhibit to attract attention was the magnificent display made by the B.H. Stief Jewelry Company. In its beautiful pavilion, on the right of the main cross aisle, is a collection of cut glass, diamonds, and silverware. Gold and gems filled out the exhibit and made it a complete and fully equipped jewelry store, where visitors could buy souvenirs. One day, a million dollar diamond collection was shown.

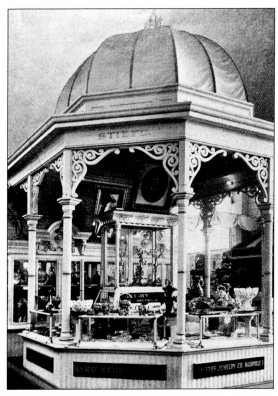

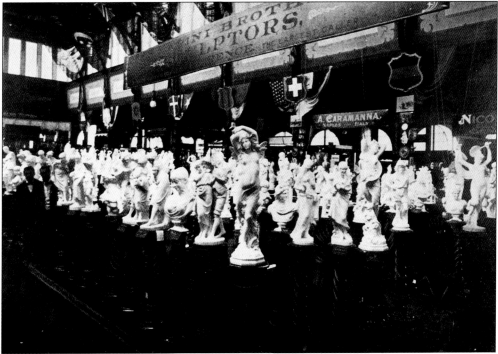

COMMERCE BUILDING DISPLAY OF ITALIAN SCULPTURE. This beautiful exhibit in the foreign section was a great collection of marbles shown by Lapini Brothers of Milan, Italy.

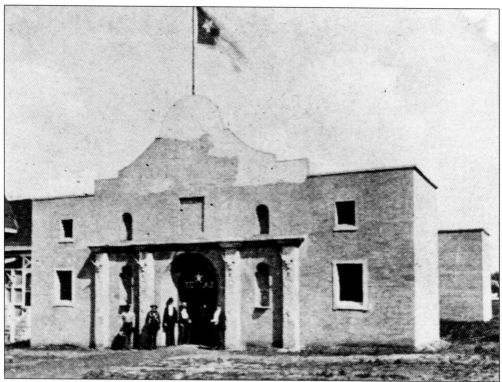

THE TEXAS BUILDING. This structure was situated on Capital Avenue and was modeled after the Alamo. June 24 was chosen as Texas Day, and this building served as the headquarters for the Lone Star State's delegation. The Crockett Clan, Davy Crockett's descendants, held a reunion here on October 1.

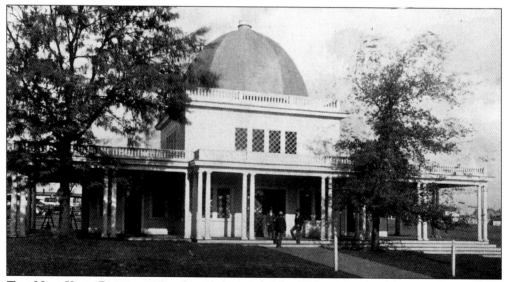

THE NEW YORK BUILDING. October 11 was Brooklyn Day, and it was celebrated in a great manner. A distinguished delegation came from New York and was honored on that day. The day's activities included military parades, music by Fischer's Centennial Band, and orations by Mayor Wurster of Brooklyn and Lieutenant Governor Wooduff.

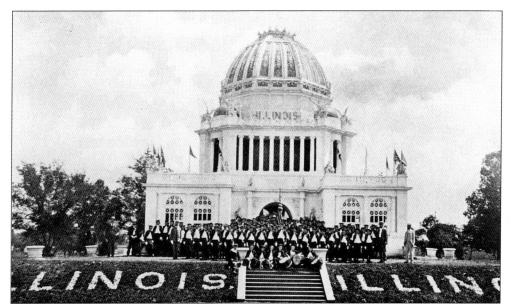

THE ILLINOIS BUILDING. The beautiful reproduction of the Columbian Exposition Administration Building stood at the end of Capital Avenue. The celebrated Armour Drill Corps is grouped in front. The visit of this organization's members is well remembered because their drilling and their musical entertainments were much praised during the two days the group spent in Nashville.

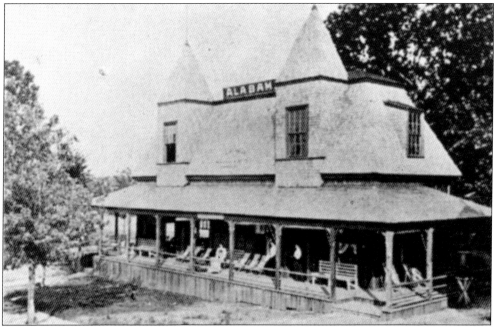

THE ALABAMA BUILDING. Alabama Day was the last "State Day" to be celebrated at the Exposition due to a yellow fever epidemic in that state. The day was postponed until October 22. The Alabama Club was responsible for receiving Alabamians into Nashville. The day included a parade to the grounds, exercises in the Auditorium, and orations by Governor Johnston and General Joseph G. Wheeler.

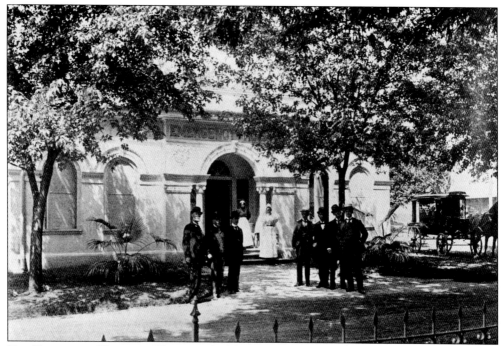

THE EMERGENCY HOSPITAL. This was a building which was generally overlooked by the average fairgoer unless he had to be taken there for some injury. The photograph shows, from left to right: Dr. Plunket, Dr. Buist, Dr. Barr, and others. The ambulance is seen to the right of the hospital.

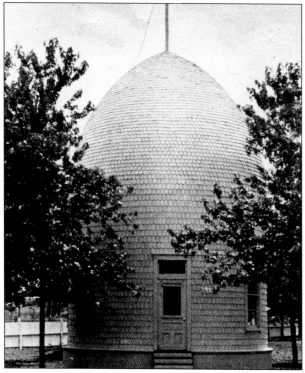

THE BEE HIVE OF THE MACCABEES. The Maccabees were only one of the many organizations represented at the Exposition with buildings and special days. Other groups included the Concatonated Order of Hoo Hoo, the Brothers of Friendship, and the Sisters of the Mysterious Ten.

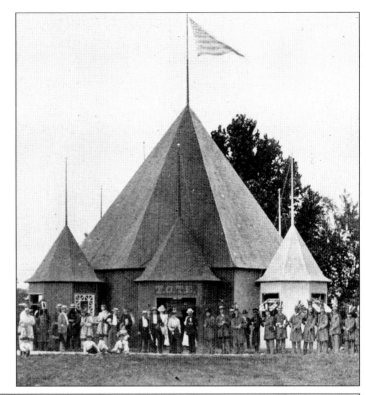

THE RED MEN'S TEPEE. The headquarters of the Improved Order of Red Men is shown. Its members dressed up like "Indians" complete with warpaint and feathers. They practiced "Indian" customs and even played the role of the foes of Custer and the Seventh Cavalry in the sham battle recreation of the fight at the Little Big Horn during military week in August.

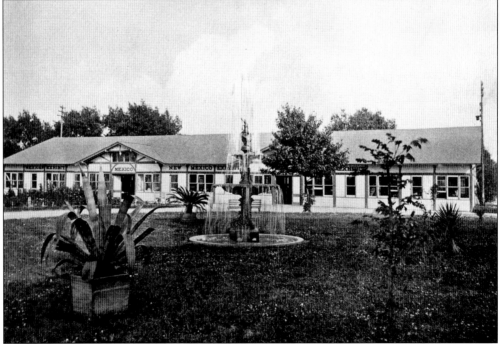

THE SOUTHERN REPUBLICS BUILDING LOCATED ADJACENT TO THE WOMAN'S BUILDING. The building housed exhibits from Mexico and Central America. The ancient Aztec relics on display were reported to be one of the finest collections found in the country.

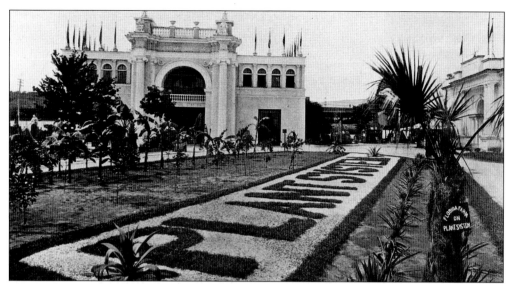

THE TROPICAL EXHIBIT OF THE PLANT SYSTEM IN FRONT OF THE TERMINAL BUILDING. The intention of this exhibit was to transplant a typical west coast Florida farm and a miniature of the Tampa Bay Hotel park. Flower beds were blooming in profusion beneath the palm, banana, orange, and Indian rubber trees. Other plants included pineapples, sugar cane, sea island silk cotton, and Cuban tobacco.

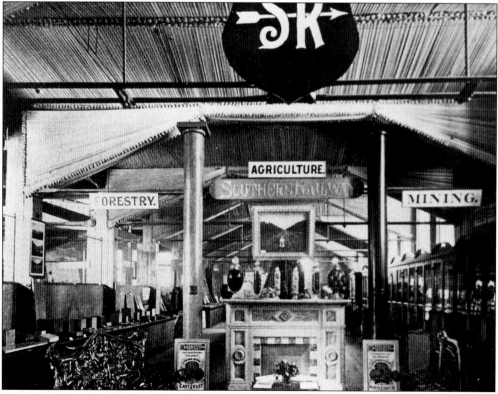

SOUTHERN RAILWAY EXHIBIT IN THE TERMINAL BUILDING. This exhibit displayed forestry, mining, and agricultural products brought in from all the states served by the railroad.

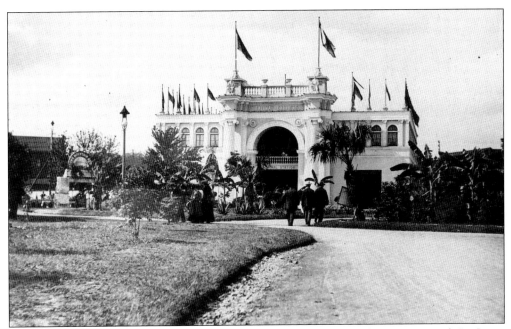

THE TERMINAL BUILDING. Where the tracks of the Nashville, Chattanooga and St. Louis Railway entered the grounds there was an ornamental Terminal Station, which is shown above. One hundred feet square and exquisitely designed, this building contained an entire exhibit of the products of the soil along the line of the railway whose enterprise erected it.

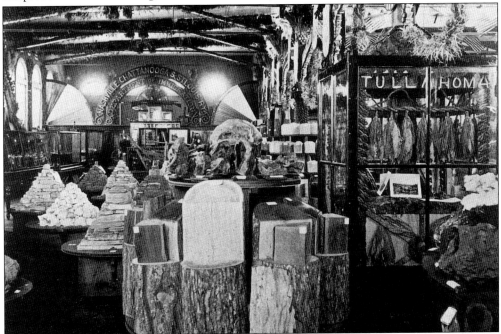

NASHVILLE, CHATTANOOGA AND ST. LOUIS RAILWAY EXHIBIT IN THE TERMINAL BUILDINGS. East Tennessee marble is pictured on the left, forestry products in the center, and to the right is the yellow tobacco grown by Mr. James G. Aydelott of Tullahoma. This experimental tobacco was also grown by the Swiss colony in Lewis County.

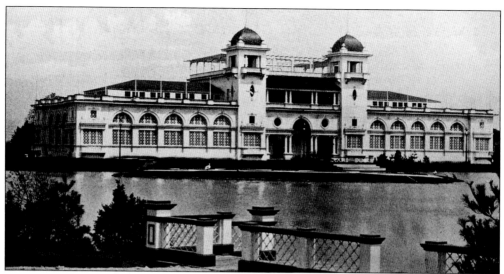

THE NEGRO BUILDING FROM THE WEST BANK OF LAKE WATAUGA. The ornate Spanish Renaissance-style architecture was used in the design of this building with its picturesque towers, red roof, and roof garden. This made the building one of the most beautiful on the grounds. The cornerstone was laid on March 13, 1897. The ceremonies included music, poetry reading, and addresses by the executive committee members. The orator of the day was professor W.H. Council, the principal of the Agricultural and Mechanical College for Negroes in Normal, Alabama.

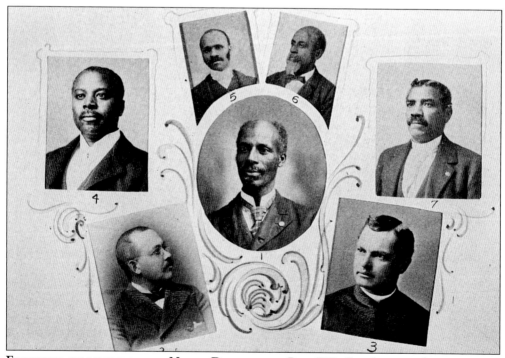

EXECUTIVE COMMITTEE OF THE NEGRO DEPARTMENT. Rev. T.E. Crawley is in the center, and the other members are, from left to right, as follows: (front row) Dr. F.A. Stewart, Rev. Preston Taylor; (back row) S.A. Walker, W.T. Hightower, Rev. R.B. Vandervil, and Thomas Tyree.

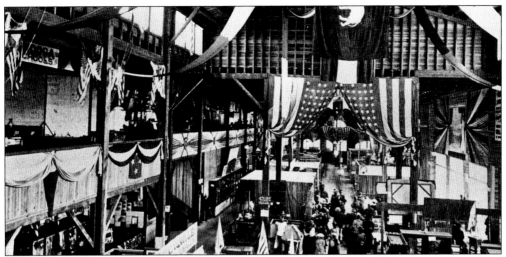

INTERIOR OF THE NEGRO BUILDING. There were over 300 exhibitors from 85 cities with displays which included information on education, science, technology, banking, and art. Fisk University's exhibit showed the unlimited possibilities for blacks in higher education. Tuskeegee Institute in Alabama was well represented with Booker T. Washington being the featured orator on Emancipation Day, which was September 22. The Watauga Cafe on the lower level provided some of the finest southern cooking found anywhere in Nashville.

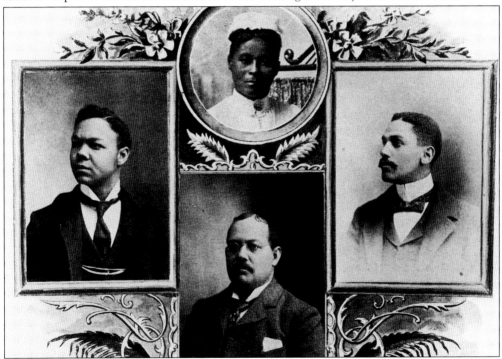

THE NEGRO HOSPITAL STAFF. The Negro Hospital, officially known as Sub-Station A, had a hospital staff composed entirely of African-Americans. From left to right, Dr. Charles Sunday, Meharry class of 1898, resident physician; Dr. F.A. Stewart, Harvard class of 1888, assistant surgeon; Dr. James R. White, Meharry class of 1897, resident physician; and Miss Maria Stewart, nurse, comprised the core of the staff. Dr. Stewart gave of his time without remuneration.

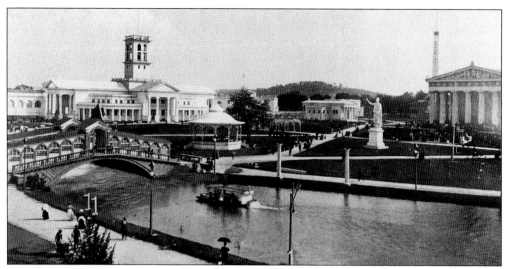

VIEW OF THE AUDITORIUM ACROSS LAKE WATAUGA FROM THE NEGRO BUILDING. The steamboat on the lake was named the *Huck Finn*. It was built on the banks of Sycamore Creek near Ashland City by a young black boy named James Hyde. He was only 13 years of age, and, for a small fare, he would take passengers on a tour of the lake.

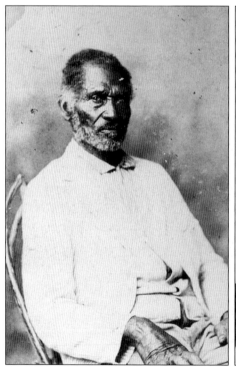 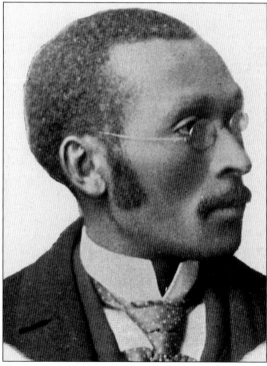

Left: "UNCLE ALFRED" OF THE HERMITAGE. *Right:* MR. RICHARD HILL, CHIEF OF THE NEGRO DEPARTMENT. A respected school teacher and leader in Nashville's African-American community, Mr. Hill was named as chief of the Negro Department for the Tennessee Centennial Exposition. Mr. Hill received praise for the success of the popular Negro Building. (Left photograph courtesy of Peggy Dillard.)

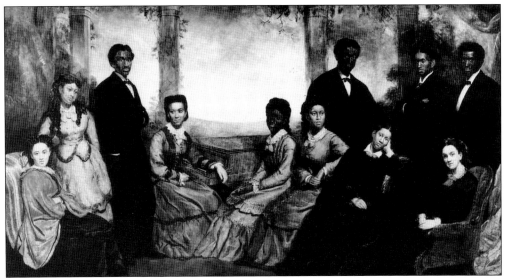

PHOTOGRAPH OF 1873 PAINTING OF THE FISK JUBILEE SINGERS. (1897 photograph not available.) The famous group from Fisk University performed on numerous occasions throughout the 6-month length of the Exposition, the most notable being Negro Day on June 5, Fisk University Day on June 14, Emancipation Day on September 22, and Ohio Day on June 11, when President McKinley and his staff visited the centennial celebration. (Courtesy of Fisk University.)

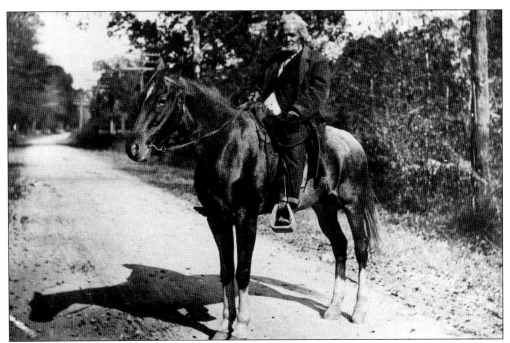

"UNCLE BOB" GREENE, HEAD HOSTELER AT THE BELLE MEADE PLANTATION. The Belle Meade Plantation was one of the premier horse farms in the state. Bob Greene was in charge of the raising of the thoroughbreds. Tours of the plantation grounds were conducted during the Exposition. General Billy Jackson's deer park at Belle Meade was a favorite destination for fairgoers who wished to tour the scenic Nashville countryside. (Courtesy of TSLA.)

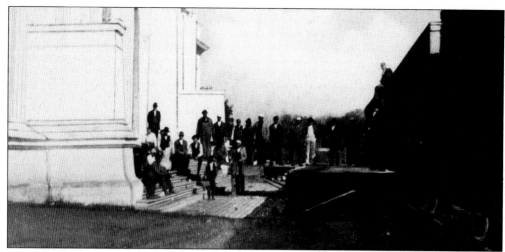

UNITED STATES GOVERNMENT BUILDING, SHOWING THE PLATFORM FOR UNLOADING EXHIBITS. The Nashville, Chattanooga and St. Louis Railway Company extended its tracks to the east end of the Government Building where exhibits from ten different departments were transferred from the railroad cars to the interior of the building. Exhibits included the following: the Smithsonian Institution, National Museum, and its other dependencies; the Post Office Department; the Department of State; the Treasury Department; the Department of Agriculture; the War Department; the Department of the Interior; the Department of Justice; the Navy Department; and the Commission of Fish and Fisheries.

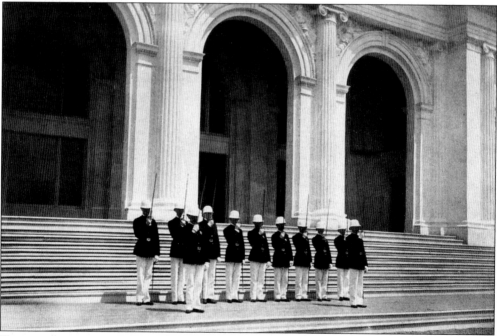

THE GUARD FORCE ON THE NORTH FRONT STEPS OF THE UNITED STATES GOVERNMENT BUILDING. During the Exposition, the building was open to the public from 9 a.m. to 6 p.m. in the afternoon. For the comfort of visitors, electric fans were distributed throughout the building, and in the aisles and open spaces a number of chairs and settees were placed. The guards, in addition to their policing duties, provided information to visitors and served as guides.

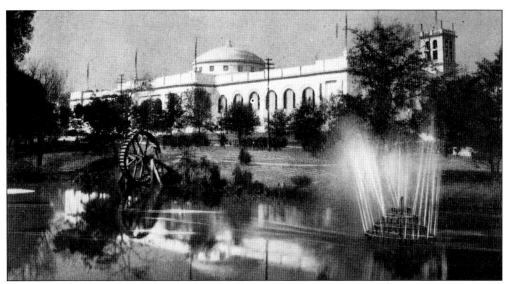

UNITED STATES GOVERNMENT BUILDING, LOOKING NORTHWEST ACROSS LAKE KATHERINE. The building was near the main entrance of the Exposition grounds, about 200 feet south of the Auditorium. The style of architecture was of the classic order. The building proper was long and low, surmounted by a central dome, with pavilions at each corner bearing flagstaffs from which flew the national ensign.

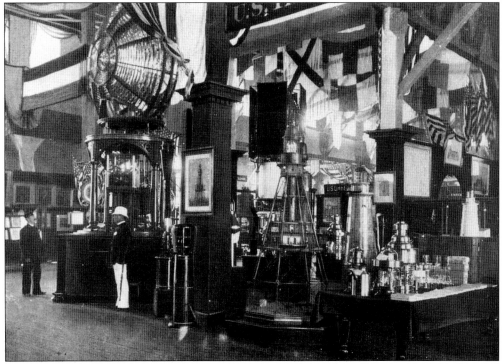

THE TREASURY DEPARTMENT'S LIGHTHOUSE ESTABLISHMENT. This was a complete exhibit of all the lenses and lanterns used in the lighthouse stations of the government. The principal feature of this exhibit was a second-order bivalve lens in operation, which was lit by electricity. It was part of the most impressive exhibit in the Government Building.

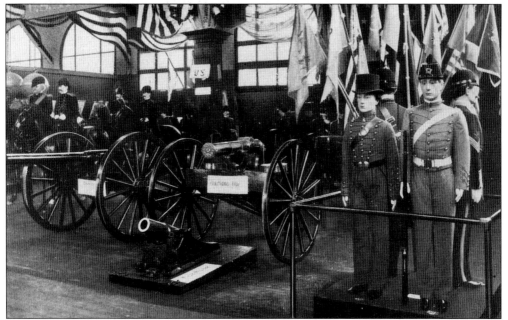

THE WAR DEPARTMENT'S EXHIBITS OF GUNS AND UNIFORMED FIGURES. The exhibits only represented four branches of the army, namely the quartermasters, engineers, ordinance, and signal corps departments. The War Department, headed by Capt. Henry C. Ward of the 16th U.S. Infantry, exhibited a large collection of guns, and cavalry and infantry soldiers' equipment and artifacts, such as a silken guidon of the 7th cavalry of Custer fame.

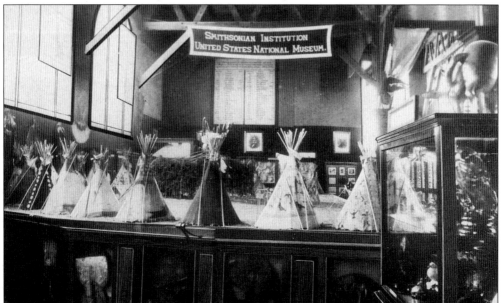

THE BUREAU OF AMERICAN ETHNOLOGY EXHIBIT. A model of a Kiowa Indian camping circle, this entire display was the work of Kiowa Indians. The exhibit was prepared and installed by Mr. James Mooney of the bureau. The insignias emblazoned on the teepees and shields were done in great detail, and the skin tents were reduced in size from 16 to 18 feet in height to 2 1/2 feet.

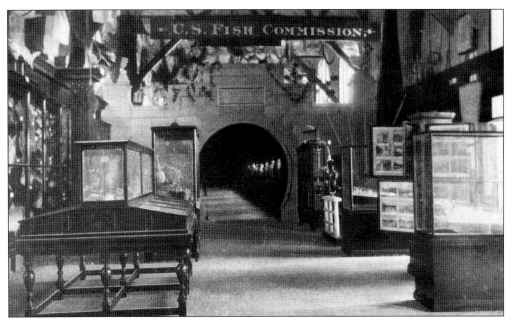

COMMISSION OF FISH AND FISHERIES' AQUARIUM. The aquarium was a grotto-like, L-shaped structure. It was 120 feet long and 28 feet wide, containing 22 12-foot wide tanks, arranged on each side of the passageway. Fresh-water and salt-water species were exhibited and included tropical fish and crustaceans. Salt water was brought in from the North Carolina coast in tanker cars for the salt water tanks, and fresh water was obtained from an 84-foot well near the southeast corner of the building.

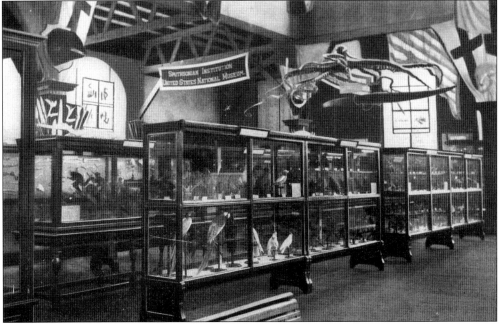

THE NATIONAL MUSEUM EXHIBIT'S DEPARTMENT OF BIRDS. The birds were exhibited in four cases on the main aisle. One case contained the parrot family and another a faunal collection from British Guiana in South America.

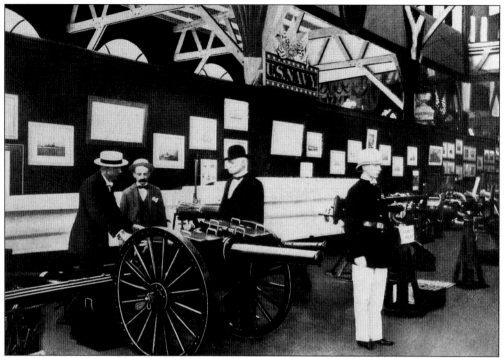

THE NAVY DEPARTMENT EXHIBIT'S GATLING GUN. Among the curiosities found in this section was a Spanish gun made in 1490 brought over by Cortez, a mortar captured at Yorktown in 1781, a Mexican gun captured in 1847, and an Alaskan Indian casket for the ashes of the dead.

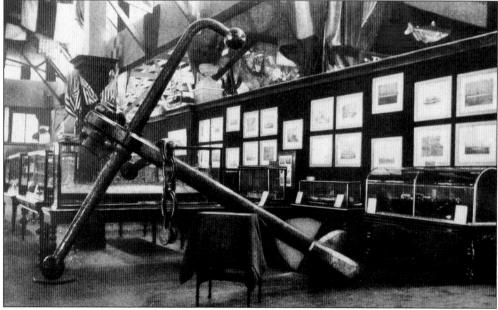

THE NAVY DEPARTMENT'S 14,000-POUND ANCHOR. This exhibit was situated in the Bureau of Equipment. This area contained cases of navigation instruments such as compasses, sextants, telescopes, aneroid barometers, psychrometers, and general service signals.

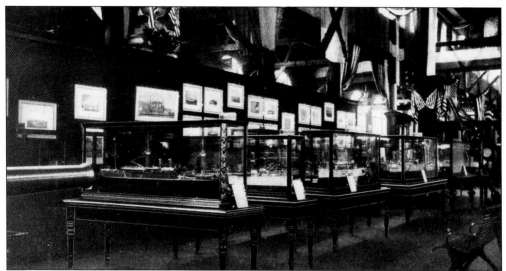

THE NAVY DEPARTMENT EXHIBIT'S MODELS OF VESSELS. Among the more interesting pieces in this section was a model of the U.S. gunboat *Nashville*, a watercolor of the *U.S.S. Nashville*, and a handsome table and showcase, in which was displayed a silver service. After the Exposition, the silver service was presented to the *U.S.S. Nashville* by the citizens of Nashville, Tennessee.

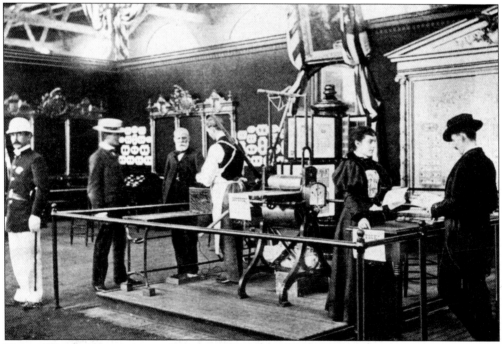

UNITED STATES GOVERNMENT BUILDING, TREASURY DEPARTMENT EXHIBITS: THE MINT AND BUREAU OF ENGRAVING AND PRINTING. The Bureau of the Mint exhibited a coin press from the Philadelphia Mint, which was run daily and struck a souvenir medal for the Exposition authorities. The Bureau of Engraving and Printing displayed a late printing press in operation, upon which were printed souvenir cards, vignettes of the White House and the Capitol, and portraits of the president and vice president of the United States.

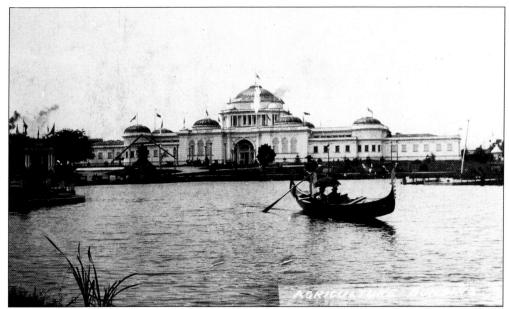

THE AGRICULTURE BUILDING ACROSS LAKE WATAUGA. This building, which had a central dome surrounded by six smaller domes, formed a keystone to the great arch of structures. An old-time cotton press is situated in front of the left wing of the building. A Venetian gondola plies the waters of Lake Watauga in the foreground. (Courtesy of TSLA.)

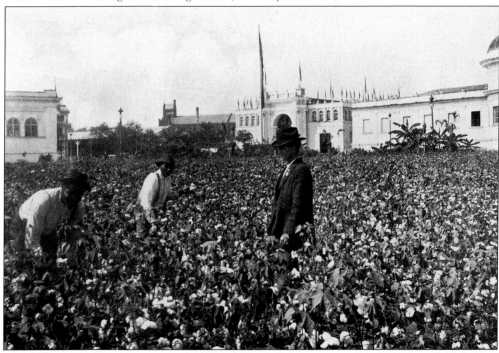

THE COTTON PATCH IN FRONT OF THE AGRICULTURE BUILDING (LEFT) AND THE MACHINERY BUILDING (RIGHT). The cotton is in full bloom in this photograph. The two men who are engaged in tending to the cotton had charge of the planting of it and are the ones who finally gathered the crop.

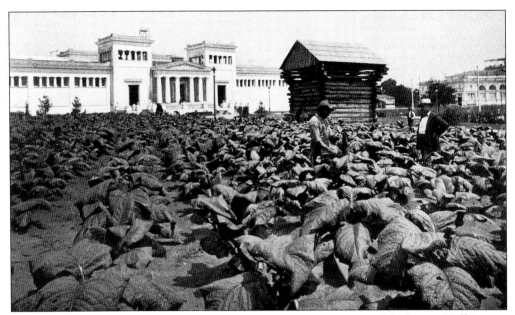

THE TOBACCO FIELD LOCATED TO THE RIGHT OF THE COTTON PATCH. Machinery Hall is seen in the background. The tobacco exhibited is of the dark-fired variety. Joseph Washington of Robertson County was responsible for preparing this outdoor exhibit, including the log tobacco barn.

THE TOBACCO DOME IN THE AGRICULTURE BUILDING. Tennessee and Kentucky had full lines of tobacco on exhibit. The ornamentation in this dome, under which the exhibits were arranged, was entirely made of tobacco leaf. There were ropes, scrolls, and many other forms represented. The tobacco of every tobacco-raising country was shown.

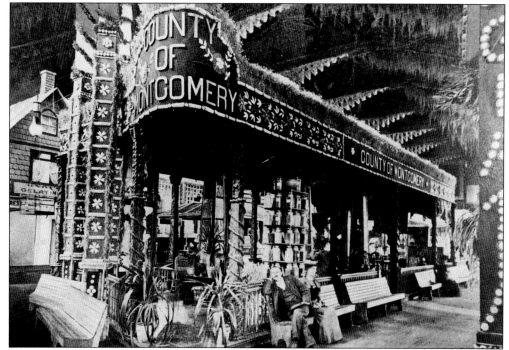

THE MONTGOMERY COUNTY DISPLAY IN THE AGRICULTURE BUILDING. In keeping with two of the themes of the Exposition, agriculture and industry, the citizens of Montgomery County prepared an elaborate exhibit consisting of grain, fruits, tobacco, etc. that showed the varied and rich resources of that county.

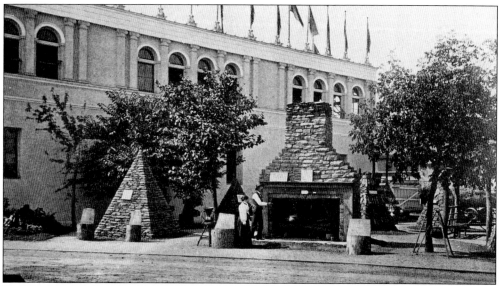

THE OUTDOOR DISPLAY OF THE NASHVILLE, CHATTANOOGA AND ST. LOUIS RAILWAY. Looking from the Agriculture Building, this display can be seen with the Terminal Building in the background. The old-time chimney and mantel are in the scene. The pyramids of ores, phosphates, iron ore, and coal are seen under the trees. The crane and the old-time pot before the fire make the scene representative of pioneer times in Tennessee.

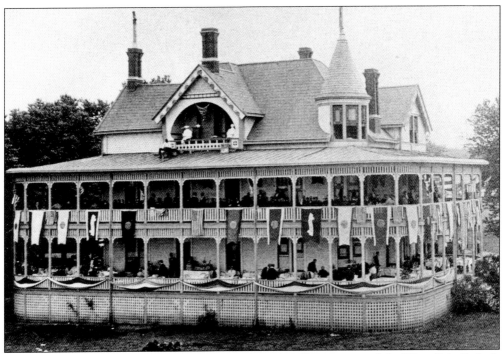

THE WEST SIDE CLUBHOUSE. The clubhouse was originally constructed for West Side Park. It was converted to a restaurant at the opening of the Exposition. This photograph was taken on the occasion of the visit of President McKinley. The distinguished party had private rooms in the interior and, after a rest from the exercises of the day, came out on the broad balconies to dinner. The banners bearing the names of all the states and their coats of arms were draped over the upper balcony banisters.

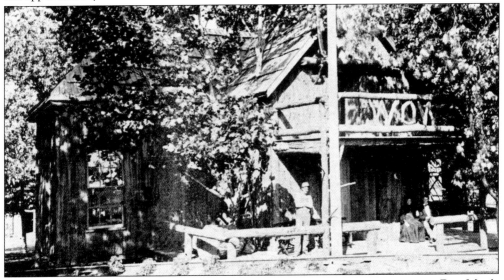

THE WOODMEN OF THE WORLD HEADQUARTERS BUILDING SITUATED NEXT TO THE RED MEN'S TEPEE. Inside were received the members of this fraternal organization. Other fraternal groups represented at the Exposition included the Knights Templar, the Knights of Pythias, the Order of Ancient Hiberneans, and the Order of Odd Fellows.

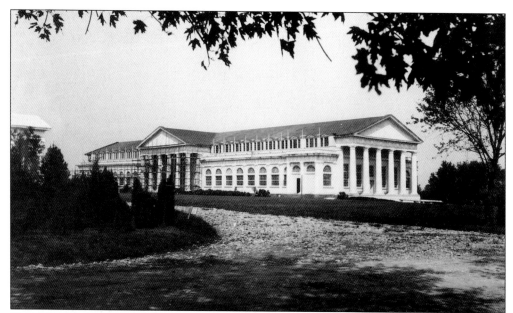

THE MINERALS AND FORESTRY BUILDING UNDER CONSTRUCTION. Of the Roman-Doric order of architecture, this building had three porticos, each with six columns and crowned with sculptured gables. Inside the structure were elaborate displays of Tennessee's forestry and mineral products. (Courtesy of TSLA.)

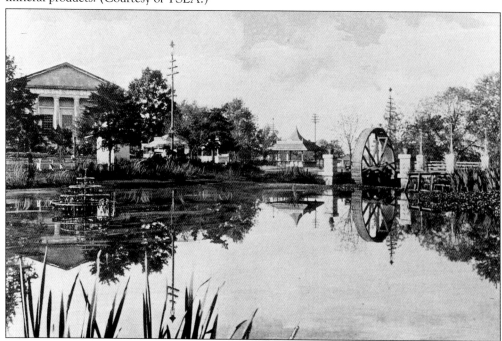

LAKE KATHERINE, NAMED AFTER "BONNIE KATE," TENNESSEE'S FIRST GOVERNOR'S SECOND WIFE. She was credited with saving her husband from Indians. The dam and waterwheel are to the right. The waterwheel came from an area near Nashville called the Leatherwoods. A Lithia water stand is just beyond the dam, and the south end of the Minerals and Forestry Building is to the left.

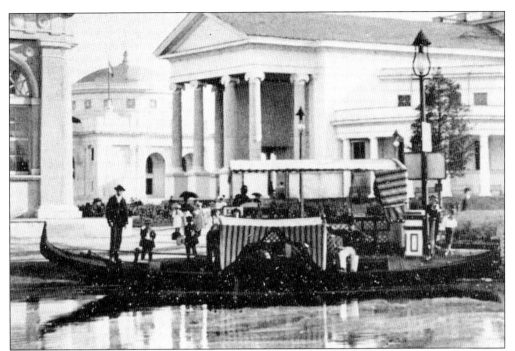

VENETIAN GONDOLA ON LAKE WATAUGA. Six Venetian gondolas skimmed across the waters of the lake. Rides cost 10¢, and the gondoliers would sing love songs to sweethearts in Italian as the long barges floated along the lazy waters. The Minerals and Forestry Building (left), Government Building (center), and the Auditorium (right), are seen in the background.

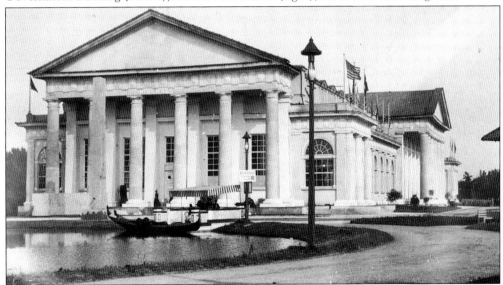

THE NORTH END OF THE MINERALS AND FORESTRY BUILDING. A gondola is moored at the landing on the south corner of Lake Watauga. The building and its annex contained a total of 76,888 square feet of floor space. Numerous lumber companies had displays inside. Native woods were shown along with imported woods. One of the favorite exhibits was that of the largest poplar tree on record, which began growth 200 years before Columbus discovered America. (Courtesy of TSLA.)

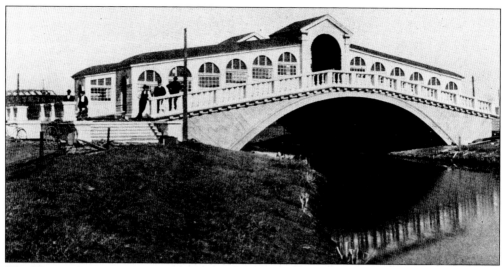

THE RIALTO BRIDGE ACROSS LAKE WATAUGA. With their bicycles parked at the east end of the bridge, workers are taking a break as they put the finishing touches on the Rialto, which connected the terminus of Capital Avenue with the east entrance to the Parthenon. The Purity Grotto is just to the left of the bridge. (Courtesy of TSLA.)

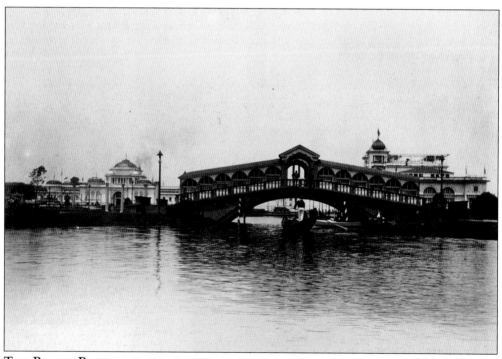

THE RIALTO BRIDGE LOOKING NORTH FROM THE NORTH PORTICO OF THE MINERALS AND FORESTRY BUILDING. A gondola is passing just underneath the bridge. The Blue Grotto (left), Agriculture Building (center), and the Negro Building (right), are situated in the background. (Courtesy of TSLA.)

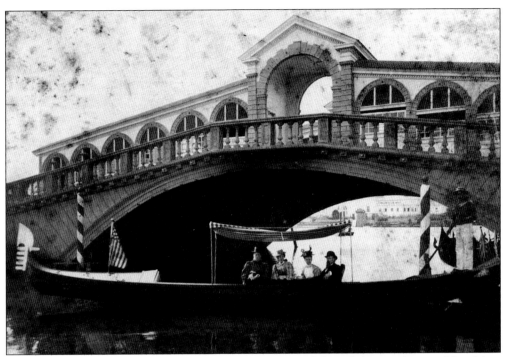

FAMILY IN GONDOLA UNDERNEATH THE RIALTO. Pictured from left to right are: Miss Mary Nichols, Miss Francis Nichols, Mrs. George S. Nichols, and Mr. Charles W. Suguines. The Rialto housed shops where fairgoers could purchase a variety of centennial souvenirs. The bridge was lit at night with numerous incandescent lamps which reflected off of the surface of Lake Watauga. (Courtesy of TSLA.)

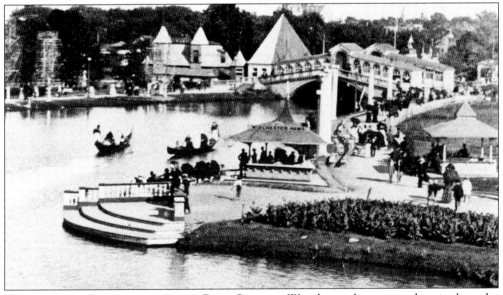

VIEW OF LAKE WATAUGA FROM THE BLUE GROTTO. Winchester hams are advertised on the sign above the gondola landing pavilion. Crowds make their way along the west bank of the lake. The Alabama Building (left), the Tepee of the Red Men (center), and the Rialto are in the background.

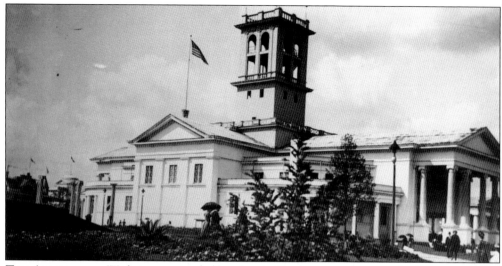

THE AUDITORIUM. With its massive belfry, the Auditorium was the site of a large number of concerts and ceremonies during the Exposition. The bells were played on special occasions such as Opening Day, Independence Day, and Ohio Day, when President McKinley came to visit. The Auditorium seated over 6,000 people. Crowds filled the halls to hear concerts performed by Gustan Fischer's Band, the Innes Band, Victor Herbert's 24th New York Regimental Band, and others. Today, the bells hang in the Tulip Street Methodist Church in historic Edgefield. (Courtesy of TSLA.)

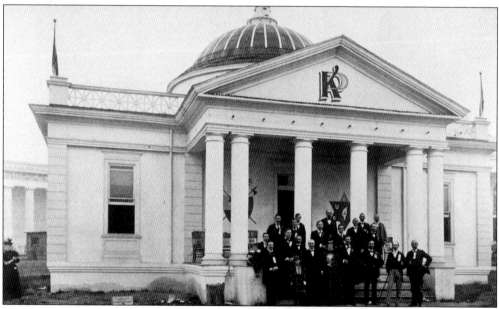

THE KNIGHTS OF PYTHIAS BUILDING. This building was erected by members of that order as a resting place and for social gatherings. A group of distinguished Pythians gathered for a photograph. Among them are most of the Grand Lodge officers of the state, including Judge S.F. Wilson, Holmes Duff, Irvine K. Chase, Trip Miller, H. White Hall, and the Supreme Secretary, Dr. R.L.C. White. The Knights of Pythias Building, modeled after Monticello, is one of only three structures that survived the Exposition. Today, the Pythias Building sits on a hill in Williamson County.

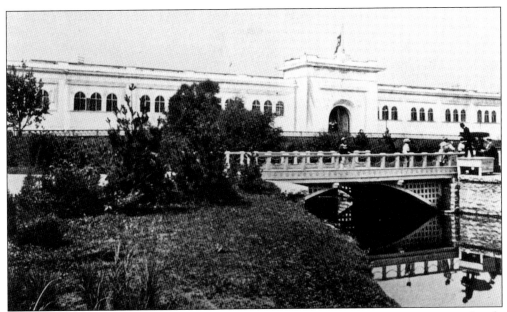

THE TRANSPORTATION BUILDING WITH THE BRIDGE OVER LILY LAKE IN THE FOREGROUND. Inside were displays of railway trains, carriages, wagons, bicycles, and all types of rolling stock. The Kentucky Wagon Company had one of the most popular exhibits. (Courtesy of TSLA.)

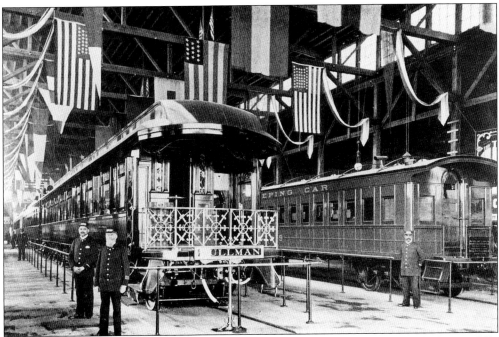

THE INTERIOR OF THE TRANSPORTATION BUILDING. Looking in from the north door, a fully equipped Pullman car is seen with conductors and porters waiting to lead the visitors on a tour. The latest design in travel, it offered passengers all of the comforts that could be had in 1897. On the opposite track is a model of the first sleeping car, so that fairgoers could compare the old to the new.

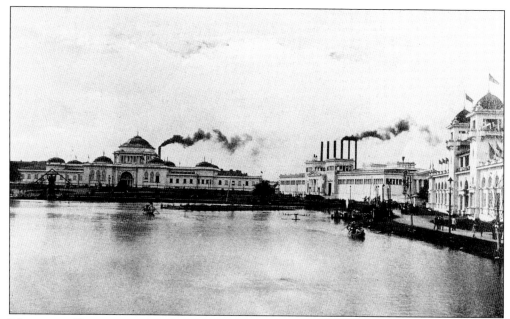

MACHINERY BUILDING ACROSS LAKE WATAUGA (RIGHT CENTER). The Agriculture Building is to the left and the Negro Building is to the right. Machinery Hall was of Greek-Doric-style architecture and displayed machinery of every variety. Two of the newest things on display were a round-bale cotton press and an automatic gear-cutting machine. (Courtesy of TSLA.)

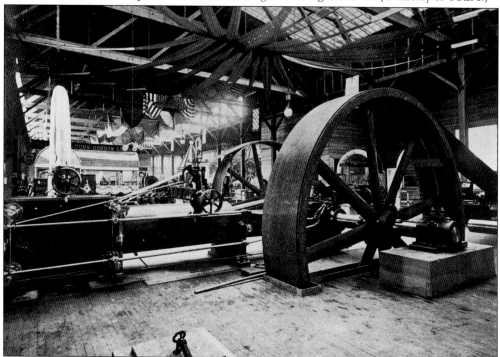

THE INTERIOR OF MACHINERY HALL. The engines pictured here furnished all of the power to run every electric light, inside and outside the buildings, and all of the arc lights on the grounds. They were designed to run with less noise and jar than a sewing machine.

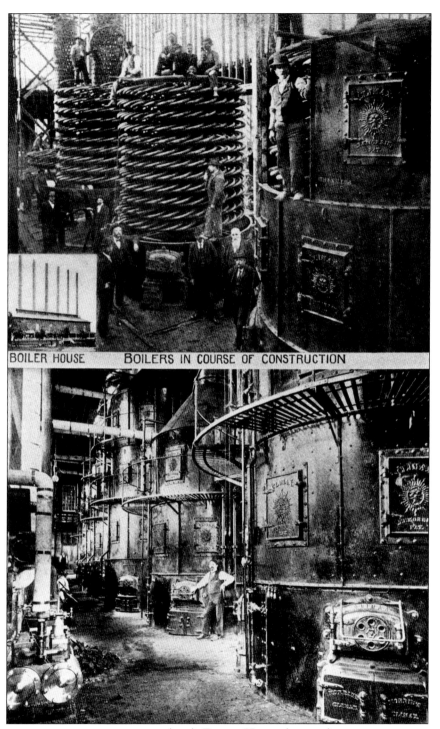

BOILERS IN COURSE OF CONSTRUCTION (TOP), BOILER HOUSE (CENTER), AND OPERATING BOILERS (BOTTOM). The boiler plant, which furnished the steam power for the Machinery Department, consisted of six Morrin Climax Vertical Water Tube Boilers. The daily consumption of coal necessary to operate these boilers was 30 tons.

DON'T FAIL TO VISIT
LION ❈ ROOF ❈ GARDEN
WHILE AT THE CENTENNIAL,
AND HEAR THE CELEBRATED
CADET ❈ BAND ❈ FROM ❈ MILWAUKEE.
FIRST CLASS RESTAURANT & CAFE.
✕ LION CINCINNATI BEER ✕
ALWAYS ON TAP AND IN BOTTLES.
DIEHL & LORD.

The beauty of the Blue Grotto is indescribable.

The Chinese Village,

THE GREATEST ATTRAC-
TION IN AMERICA TO-DAY,

The Gem of Vanity Fair.

The Monstrous Dragon Show and Joss House.

Theater and Beauty Show.
The Grand Bazaar and Tea Garden.

Dry Goods, Clothing, and other stores. Kitchen, Farming Utensils Exhibit. Barber Shops, Rice Mills, Drug Store, Military Display, etc., Opium Den and Gambling House.

ADMISSION 15 CENTS.

A Cheap but Gaudy Souvenir May please the honoree, but for a memento of which you will always feel proud, make selection at **PHILLIPS & BUTTORFF'S**.

DON'T FAIL TO SEE **GORMAN & BOONE'S**
Trained Wild Animals and Ostrich Farm.
One of the Most Refined Features of the Exposition.
POPULAR PRICES. **25 AND 10 CENTS.**

PAGE FROM AN OFFICIAL PROGRAM TO THE CENTENNIAL EXPOSITION ADVERTISING THE ATTRACTIONS IN VANITY FAIR, THE AMUSEMENT SECTION ON THE GROUNDS. (Courtesy of TSLA.)

Four

VANITY FAIR

Entertainment and amusement were a part of the make-up of the great fairs and expositions. Various shows from all parts of the globe were centered in one place on a street called the Midway. The diversified number of attractions at the Chicago World's Fair was called the Midway Plaisance. Nashville chose the name Vanity Fair. The *Nashville American* published an article on May 1, 1897, that described Vanity Fair as follows: "Here are gathered together from the far corners of the earth people representing nearly every race and nationality who with their continuous babel of unknown languages and their queer and quaint costumes present a Kaleidoscope panorama ever intensely interesting to the Centennial visitor."

Vanity Fair provided the fairgoer with a choice of strange foreign foods, including Cuban, Mexican, Italian, Chinese, German, French, Spanish, and Arabic cuisines. Visitors to Vanity Fair could step into another world and explore the streets of Cairo, a Cuban village, and a Chinese village all in one day. Exotic rides on camels and elephants were available, as well as rides in Venetian gondolas. Thrillseekers climbed aboard Barnard's Airship, rode the Giant Seesaw, and screamed as they "shot" the Chutes. Children loved Gorman and Boone's Trained Wild Animal Show with its lions and monkeys. Illusions were performed in Edison's Mirage and Spain's Palace of Illusions. The fun, the food, the excitement, the rides, and the curiosities found in Vanity Fair would be remembered by all who had an opportunity to experience them.

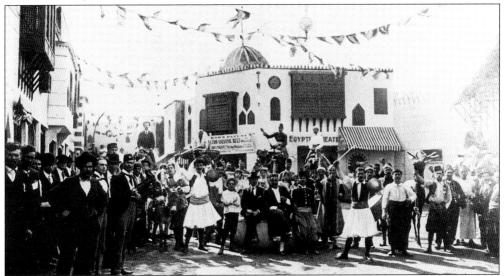

ENTRANCE TO THE STREETS OF CAIRO. In this section of Vanity Fair, fairgoers were taken into the Mediterranean world of North Africa. Strains of Arabic music were played by musicians above the main entrance. Belly dancers, called "coochee-coochee" girls, performed in the Egyptian Theatre. Swordsmen, tumblers, and conjurers entertained the crowds, and camels were available for hire.

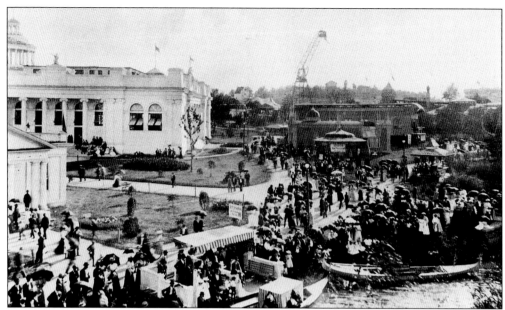

GOING TO VANITY FAIR. Throngs of people are bound for various places of amusement. Gondolas are docked in the foreground, taking on passengers for 10¢ rides. The structures, from left to right are: the Knights of Pythias Building, the Giant See-Saw (middle background), and a host of smaller buildings. Avenues lead to the See-Saw, the Chutes, the Streets of Cairo, and other attractions found in Vanity Fair.

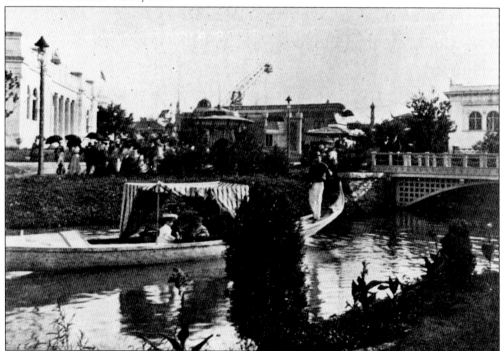

GONDOLA AT THE ENTRANCE TO THE BLUE GROTTO. The Giant See-Saw is seen in the distance on the hill. The Education Building (left), the Seaboard Air Line Palace Car (center), and the Transportation Building (right) are in the background as crowds move toward Vanity Fair.

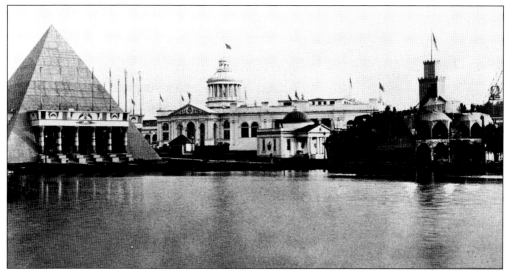

VIEW OF THE BLUE GROTTO (RIGHT) ACROSS LAKE WATAUGA. Modeled after the Blue Grotto on the Isle of Capri, visitors were able to experience the feel of going to Italy. The Gerst family operated a restaurant here where spaghetti, cappuccino, and Italian ices could be enjoyed, along with other Italian favorites. The Memphis Pyramid (left), the Commerce Building (left center), the Education Building (right center), and the little Knights of Pythias Building comprise the other structures in the photograph. (Courtesy of TSLA.)

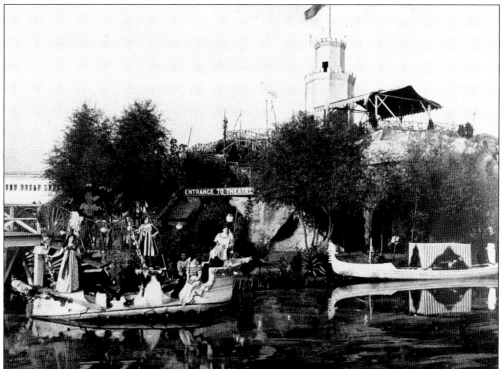

THE BLUE GROTTO RESTAURANT. The restaurant sits atop the island while the beautiful Ione, the "butterfly" dancers, and the skirt dancers perform Italian theatre on the decorated barge on Lake Watauga.

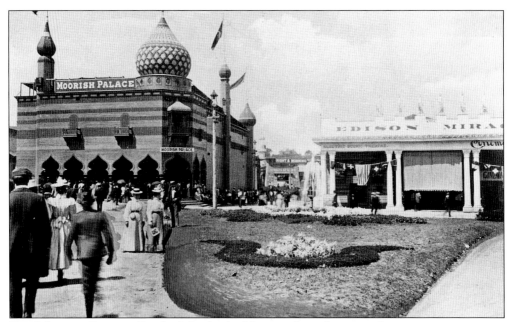

THE MOORISH PALACE. On the left, this building, with its domes, arches, minarets, painting, and decoration, gave visitors the impression of being turned loose in a corner of Algiers. Inside the Moorish Palace was a wax and art museum that featured many beautiful, many weird, and some gruesome subjects. Subjects were treated in groups, but the Chamber of Horrors was disconnected so that only those who had a bit of the morbid in their disposition could view it. The Devil's Cave and a View of Hell were among the subjects, as well as Cannibals Roasting a Prisoner and Dinah Brown the notorious "baby farmer" of New Orleans. Edison's Mirage is to the right.

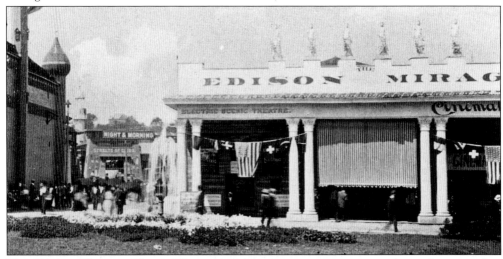

THE EDISON MIRAGE. This exhibit gave fairgoers an opportunity to choose between four different motion picture shows, the most popular being a 20-minute portrayal of *A Day in the Alps*. The Electric Scenic Theatre consisted of a vitascope, kinetoscope, verascope, and other scopes, which flashed on canvas the actual scenes of everyday life. Realistic, life-size figures were seen in motion. The audience was seated upon a revolving disk, which turned automatically, every two minutes, from picture to picture.

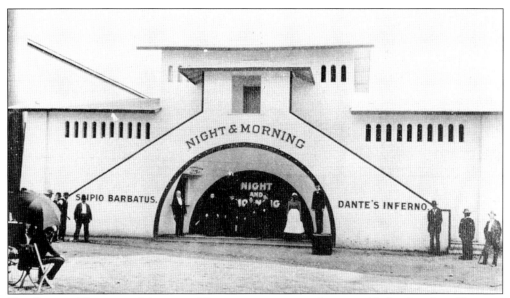

THE CAFE OF NIGHT AND MORNING. This was an attraction that resembled a chamber of horrors. Undertakers and widows greeted visitors at the door. The outside structure was shaped like an above-ground burial vault. Scenes from Dante's *Inferno* came to life as the structure's walls were lined with skeletons with burning red eyeballs. The Satin Theatre exhibited ghastly death scenes followed by scenes from a descent into hell. (Courtesy of Peggy Dillard.)

UPON ENTERING NIGHT AND MORNING. Visitors were seated for refreshments at a table made from a real coffin and hanging above were skull and bones chandeliers. After being entertained with illusions of death and horror, the visitor was led down a long dark tunnel into a room with bright lights, white satin drapes from floor to ceiling, and people singing in angelic voices behind the curtain. The visitor had been taken on a journey from hell into heaven. (Courtesy of Metro Nashville Archives.)

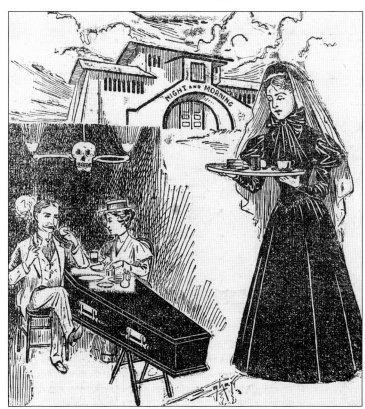

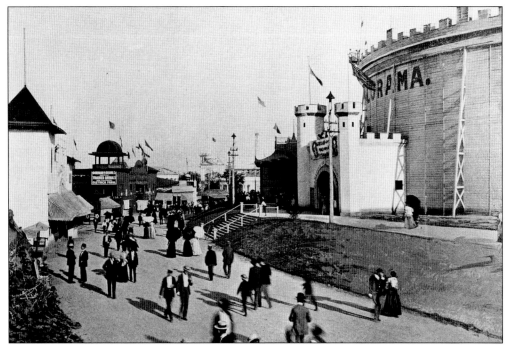

BROADWAY IN VANITY FAIR. Pictured from left to right are: the Phantom Swing, Gorman and Boone's Trained Animal Arena and Ostrich Farm, the Chinese Village, and the Cyclorama of the Battle of Gettysburg. Anthony Gorman and Col. Daniel Boone's show featured trained lions, tigers, bears, horses, dogs, and monkeys and had been performed before European and Turkish royalty.

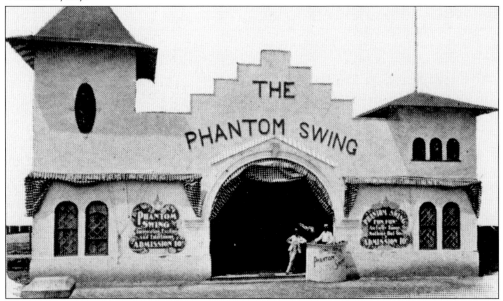

THE PHANTOM SWING. This was one of many interesting and curious sideshows that beckoned the fairgoer to come and be entertained for a cost of 10 to 25¢. Other attractions along Broadway included the Gladdish Wheel, the Ocean Wave, the Nebraska Sod House, the Old Plantation, and the Colorado Gold Mine.

THE CYCLORAMA OF THE BATTLE OF GETTYSBURG. Inside the circular walls of this building was a painting which depicted the famous charge of General Pickett's division at the stone wall on the third day of the Battle of Gettysburg. This work is said to have required 16 months of labor by 13 artists to complete. Seven tons of paint were used before the painting was finished. The exhibit was popular with Union and Confederate veterans alike and contained many relics from the War Between the States, including muskets and tattered battle flags.

LUNCH ON A BENCH OUTSIDE THE LINCOLN-DAVIS CABINS. The birthplace cabins of Abraham Lincoln and Jefferson Davis were brought to the Tennessee Centennial grounds for people to see. Portraits of the two Kentuckians hang on the columns of the entrance. One story has it that when the Exposition ended, the logs from the disassembled cabins were mixed up.

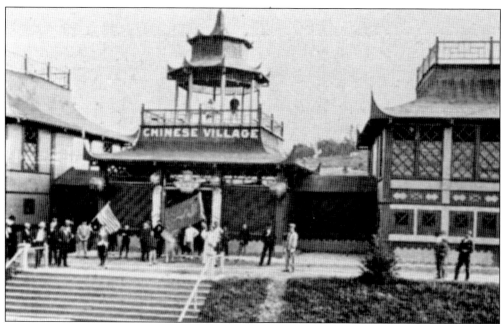

THE CHINESE VILLAGE. A banner is raised for the photographer as the Chinese assemble outside the gateway to the Chinese Village. Over 200 Chinese people were brought to Nashville for the duration of the Exposition. Inside, visitors could get an idea of what everyday life in China was like. An entire village was in full operation and was complete with gardeners, cobblers, shops, a restaurant, a Joss house (or tea house), and an opium den.

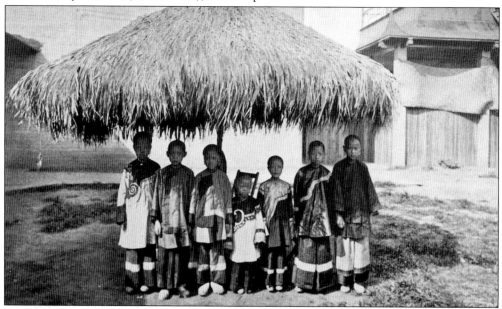

INTERIOR OF THE CHINESE VILLAGE. Oriental music was heard as visitors entered the village. The theatre was usually the first stop on the tour. A Chinese beauty show was put on in the afternoons, and the Chinese children, called "celestials" by the locals in 1897, who were brought in from the mission schools in California, would sing in pidgin English for the entertainment of the crowds.

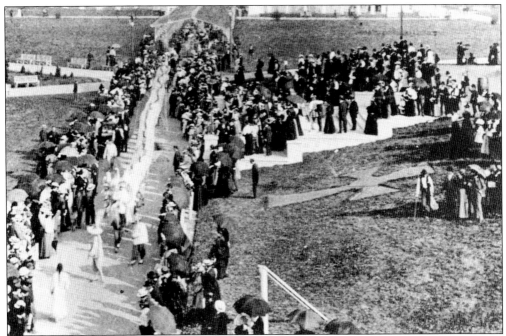

THE PARADE OF THE CHINESE DRAGON. The marchers are passing through the vine arbor heading toward the Auditorium. The Pallas Athena statue and the Minerals and Forestry Building are situated to the left. The crowds watch the sinuous procession from the steps of the east entrance to the Parthenon.

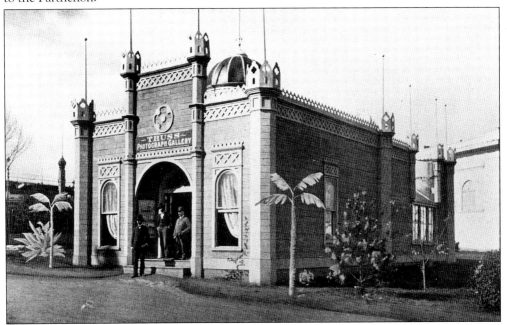

THE THUSS PHOTOGRAPHIC GALLERY. The gallery was situated at the entrance to Vanity Fair. W.G. and A.J. Thuss had the concession for all of the photographs on the grounds. Visitors could go inside and view the photographic gallery or sit for a picture themselves. Thousands of fairgoers took advantage of this and had their pictures made.

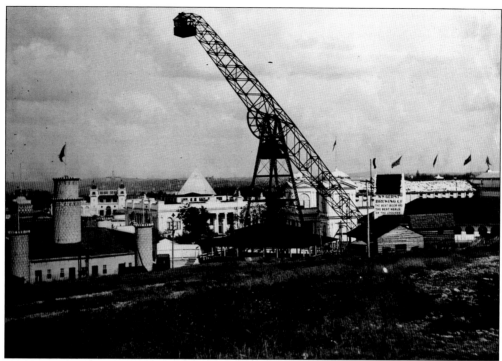

VIEW OF THE GIANT SEE-SAW FROM THE TOP OF THE HILL. Pictured here are: Spain's Place of Illusions (left), Old Vienna Restaurant (right), and two log cabins brought from the mountains of East Tennessee complete with a real working moonshine still.

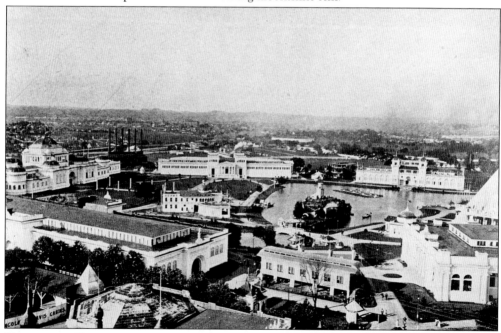

VIEW OF THE CENTENNIAL GROUNDS FROM THE TOP OF THE GIANT SEE-SAW. This was a favorite vantage point to view the fireworks displays which took place on Tuesday, Thursday, and Saturday nights at 7:30 or as soon as it got dark.

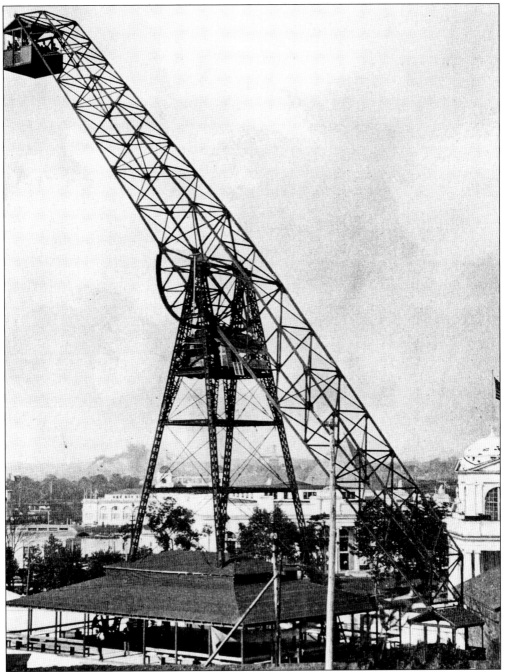

THE GIANT SEE-SAW. The invention of a local Nashville company was one of the most popular attractions in the midway section of Vanity Fair. The giant steel structure had a box on each end which could hold a score of people. The ride began after the guide locked the door. The passengers would then be lifted to a height of over 208 feet. From the vantage point atop the Giant See-Saw, the thrillseeker could see not only all of the Exposition grounds, but also the state capitol building, 2 miles in the distance, and the surrounding suburbs of Nashville. Rides on the See-Saw cost the passengers 25¢ and 10¢ for additional trips.

The Hermitage, Belle Meade, and all points of interest, can be seen from **THE SEESAW**

The Western Union Telegraph Office in the **Press** Building, near the Rialto, is open till 10:00 **P.M.**

Don't fail to see the attractions in Vanity Fair.

Buy Southern Beauty Waltz Song.

After the concert where? Blue Grotto, of course.

VICTOR HERBERT

AND HIS

FAMOUS 22d REGIMENT BAND,

OF NEW YORK.

AFTERNOON PROGRAMME—4:00 P.M.

PART FIRST.

1. March, Under the Double Eagle................J. F. Wagner
2. Overture, French Comedy......................Keler-Bela
3. Solo for Saxophone, Se tu Savais..............Wettge
 Mr. A. Laurendeau.
4. Concert Waltz, Toujours et Encore............Lamothe
5. Torchlight Dance..............................Meyerbeer

Ladies' Attendant in Dressing Room at **THE CHUTES**

If you want a first-class, up-to-date PIANO at reasonable prices, upon favorable terms, buy the STARR PIANO, Jesse French Piano & Organ Co., Manufacturers and Dealers, 240 and 242 N. Summer St., Nashville, Tenn. See EXHIBIT in Commerce Building.

PART SECOND.

6. Overture, Prince Methusalem..................Strauss
7. (a) Promenade Matinale (new)................Lacombe
 (b) Scherzo..................................Herbert
8. Solo for Bass Tubas in Unison, Celler Cool...Schlufinsloch
 Herr Schleibush, principal.
9. Potpourri, Fleur de Lys......................Delibes
10. March, Flying Colors........................Bucalossi

During this week the Evening Concerts will be held, weather permitting, three in the Band Stand and three in Auditorium.

Music and singing at intervals during the day, in the Foreign Section of the Commerce Building, by the Milan Mandolin Orchestra

Note Chimes in Auditorium at 10 a.m., 12 m., 6 p.m., and 7 p.m.

SOUVENIRS, Original in design, moderate in price at

PHILLIPS & BUTTORFF'S, North College St., bet. Church and Union.

Page from the Official Programme to the Exposition calling attention to the Vanity Fair attractions of The Chutes, The See-Saw, and the Blue Grotto. (Courtesy of TSLA.)

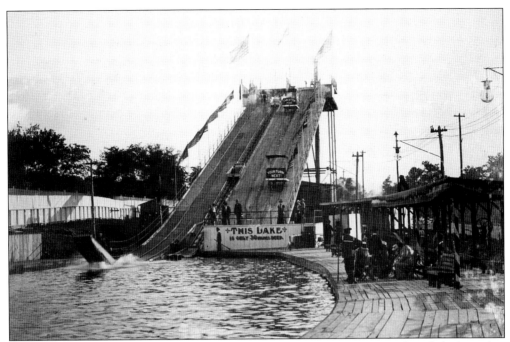

SHOOTING THE CHUTE. The Chute was a water ride in which the passenger boarded a boat that slid down a steep incline and splashed into the lake below covering onlookers with a spray of water. (Courtesy of TSLA.)

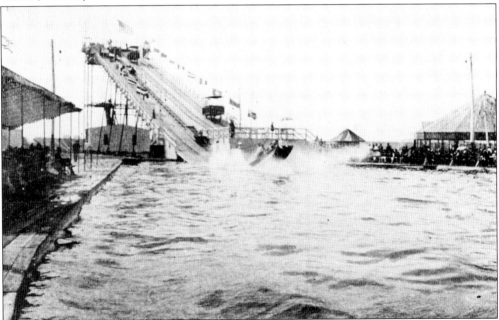

SHOOTING THE CHUTE FOR ONLY 10¢. The attraction was located at the highest point in the park. The pool of water was only 30 inches deep. Toward the end of the Exposition an unusually large woman went down the slide. When she hit the water, the bottom fell out of the boat. She started screaming because she couldn't swim, but then stood up and calmed down when she discovered that the water was very shallow. (Courtesy of Peggy Dillard.)

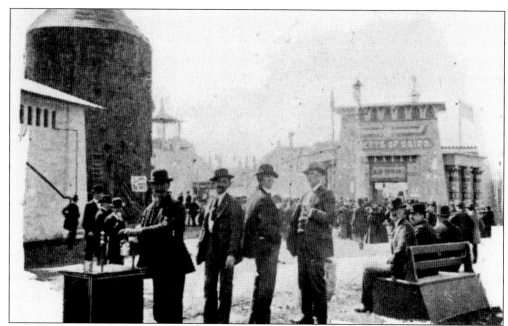
UNIDENTIFIED MAN GETTING A DRINK OF WATER NEAR THE ENTRANCE TO THE STREETS OF CAIRO, MODELED AFTER THE EGYPTIAN PALACE AT LUXOR.

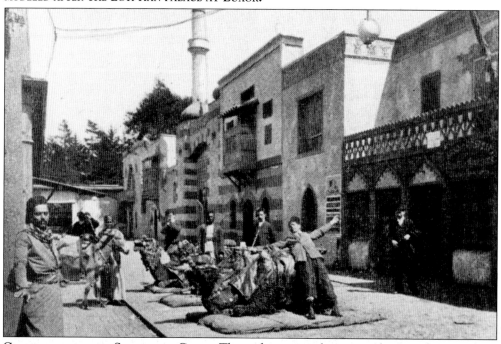
CAMEL RIDES IN THE STREETS OF CAIRO. The architecture, the music, the "coochee-coochee" girls in the Egyptian Theatre, the swordsmen, and the acrobats all drew visitors to the Streets of Cairo area of Vanity Fair. However, the camel rides atop beasts with names like Alibaba, Nancy Hanks, and Yankee Doodle Dandy for 10¢ always drew a crowd. At night, the fairgoers witnessed the excitement, as donkey races were run through the streets and were followed by confetti fights between the onlookers.

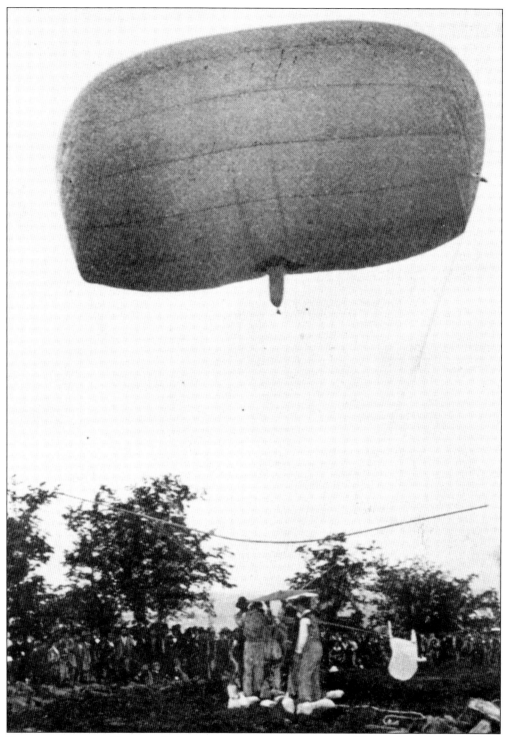

THE FIRST FLIGHT OF BARNARD'S AIRSHIP, AT THE TOP OF THE HILL IN VANITY FAIR, MAY 6, 1897.
Passengers could take a sail for several hundred feet and then be pulled back down again.

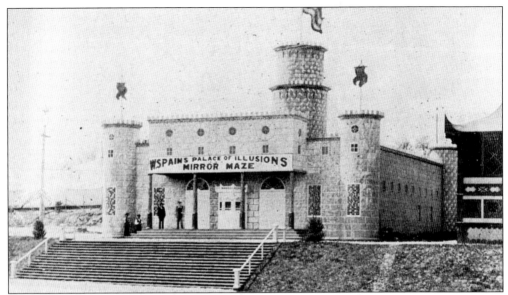

W.S. Spain's Palace of Illusions and Mirror Maze. Located to the left of the Chinese Village, this attraction was a favorite of young and old alike. The maze was difficult for many to navigate, but it was always fun and entertaining. One of the illusions was an import from Paris. A young lady took her position on the stage in full view of the audience and was turned by graduations of light into a statue or "pillar" of salt. Then the transformation was reversed.

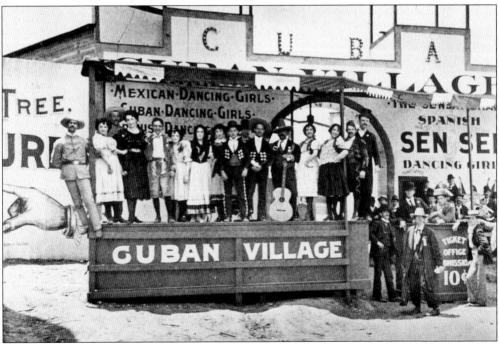

Cuban Village. Costumed dancers and musicians performed for audiences. Latin American shops, theatre, and food helped to create the atmosphere of visiting one of the "Southern Republics." Cuban cigar makers made cigars out of Havanna tobacco for the visitors. Children loved the ponies, donkeys, and the two elephants that walked the avenues.

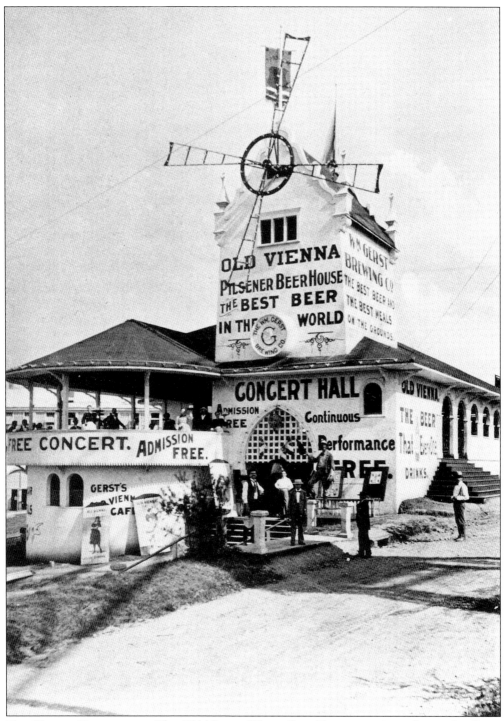

OLD VIENNA RESTAURANT. The Old Vienna Pilsner Beer House was situated near the Giant Seesaw and Vanity Fair and entertained fairgoers who needed some cool refreshment after seeing the many amusements found there. Traditional German food was served, and free entertainment was provided by a band that played Bavarian-style music.

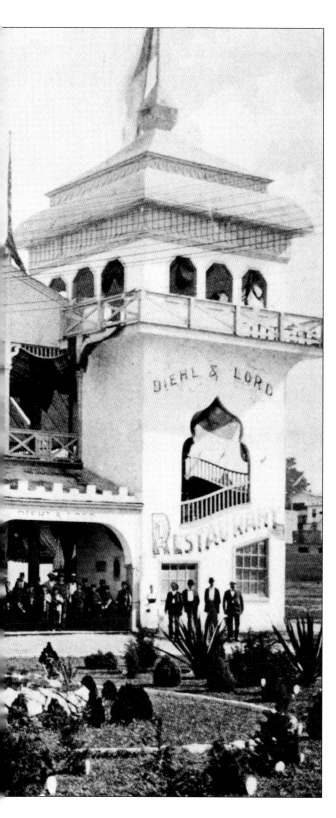

DIEHL AND LORD'S CAFE OF CINCINNATI. This cafe advertised its Lion beer to be the finest on earth. The proprietors and entertainers of this German establishment are posed in front of what fairgoers dubbed the "Lion Roof Garden." The Old Vienna restaurant and Diehl and Lord's were the favorite watering holes of the troops in the military camps.

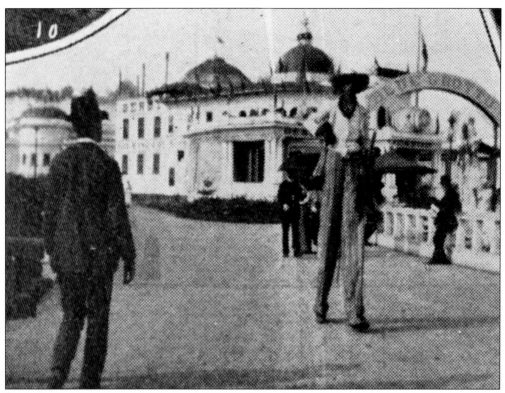

A CLOWN ON STILTS AT THE ENTRANCE TO THE BLUE GROTTO.

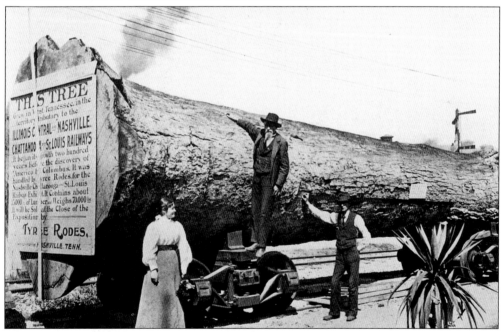

RECORD-HOLDING TREE. The big tree exhibited at the Exposition was reportedly the largest poplar tree on record, weighing over 70,000 pounds. Displayed by the Nashville, Chattanooga and St. Louis Railway, the tree was over 600 years old.

Five

SPECIAL DAYS

Special Days were an important part of the Exposition. The organizers of the Tennessee Centennial used the example of the Columbian Exposition of 1893 in planning for special days. Experience had demonstrated that the most effective way to attract attention to the Exposition was to invite as many groups as possible to hold their congresses and conventions in the host city. Special Days were designated for states, counties, and cities. They were also designated for religious groups, political groups, descendants groups, and fraternal groups.

Parades filed down the main thoroughfares of Nashville while supporters and onlookers watched the processions take place. The destination for the marchers was always the Centennial grounds. Participants in the grand parades included Knights in plumed hats with ceremonial swords; ladies in their fanciest dresses and hats riding in flower-decorated carriages; white men dressed like Indians, complete with warpaint and feathers; and "real" Indians, such as the Sioux and Cheyenne warriors who fought against Custer. Special Days that honored African Americans were celebrated with parades and special speakers. Musical performances were held daily by concert bands in the Auditorium as well as in the open-air bandstand.

The nationalities, sections, states, and all shades of political and religious beliefs came. "The Republican and the Democrat, the white man and the black man, the advocate of women's rights and her contented sister, met and had their day without hindrance or protest."*

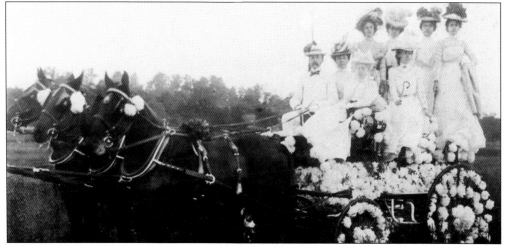

THE FLOWER PARADE, KATE KIRKMAN DAY, SEPTEMBER 30, 1897. Pictured in the photograph, from left to right are: Mr. J.H. Robinson (Gus), Mrs. J.H. Robinson, Debbie Briggs, May Lindsey, Mildred Williams, Elizabeth Plummer, Louise Louis, and Mary Bass. (Courtesy of Harriet Doerman.)

*Pages 219–20. Official History of the Tennessee Centennial Exposition. Herman Justi, Editor, Nashville: 1898.

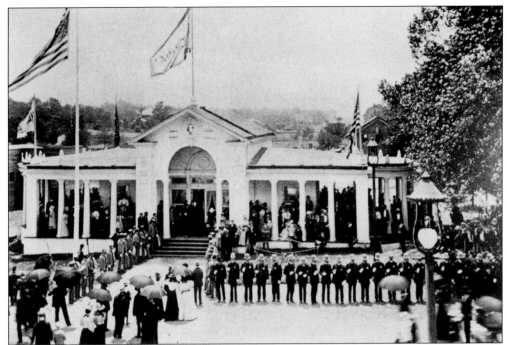

WAITING AT THE CINCINNATI BUILDING. Fairgoers are waiting for the arrival of Pres. William McKinley at the Cincinnati Building, where the exercises of Ohio Day were to be held. The crowds must be kept back, and the Centennial guards are drawn up in a line on each side of the avenue. On the right is a detachment of the Nashville police, there to assist in maintaining order. The people standing inside the building are those who were fortunate enough to be on the program or officially connected with the day's exercises.

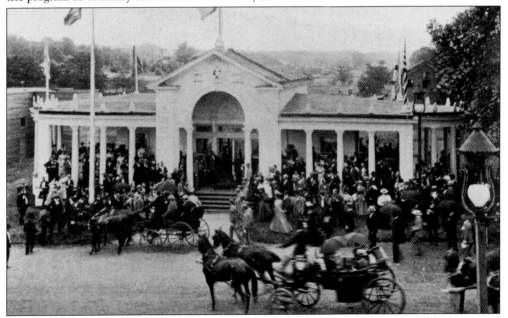

PRESIDENT MCKINLEY'S ARRIVAL AT THE CINCINNATI BUILDING. June 11th was designated as Ohio Day, and the crowd greeted President McKinley with tumultuous applause.

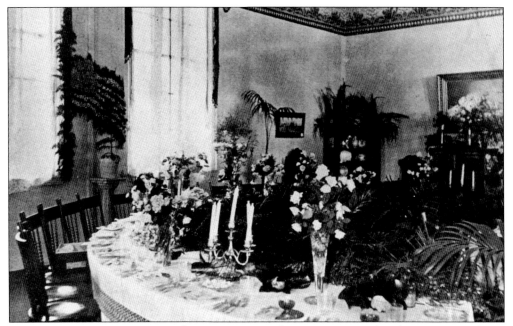

THE WOMAN'S BOARD DINNER. The Woman's Board gave Mrs. McKinley the most magnificent dinner ever served in their building. This view shows the seat occupied by Mrs. McKinley under the floral flag, her chair elaborately decorated in ribbons of the national colors.

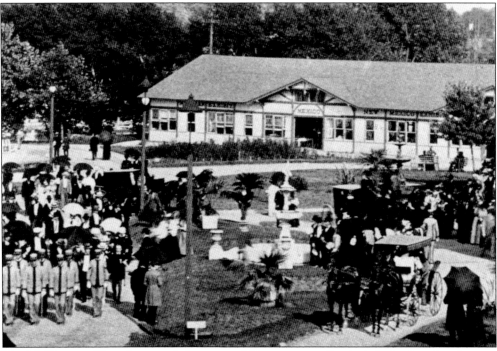

THE MCKINLEYS. This photograph shows two different scenes. On the left, the President has just started on a tour of the grounds with his escort. On the right, the vast crowd is still pressing to obtain admission to the reception for Mrs. McKinley in the Woman's Building. The reception was overwhelming, and Mrs. McKinley was overcome by the heat.

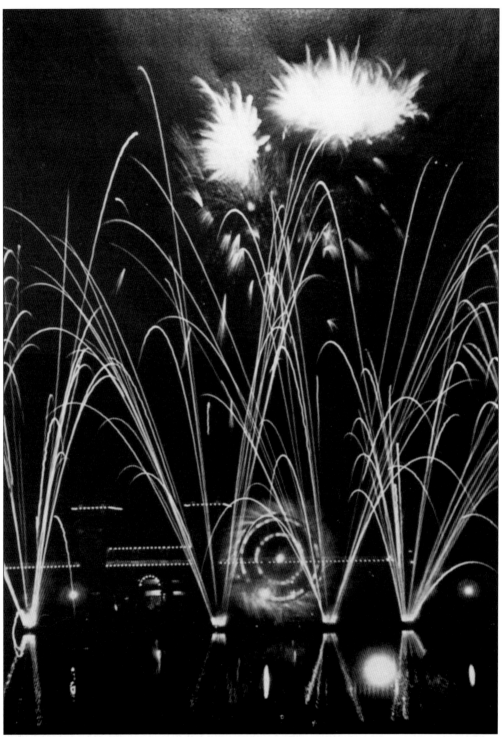
THE EVENING FIREWORKS DISPLAY HONORING PRESIDENT MCKINLEY ACROSS LAKE WATAUGA. The great wheel is seen, along with the bursting white rockets. The outline of the Negro Building is seen in the background.

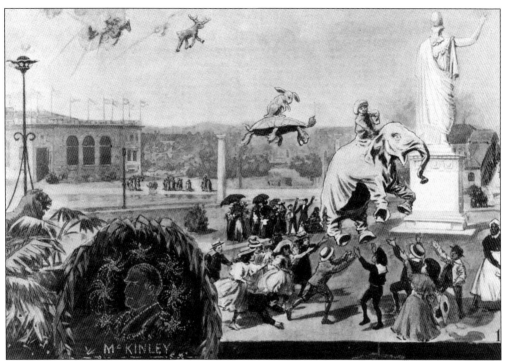

HARPER'S WEEKLY MAGAZINE ILLUSTRATION OF THE DAYTIME FIREWORKS DISPLAY STAGED FOR PRESIDENT MCKINLEY. The animal figures were shot out of cannons and floated down from the skies to the delight of the children. (Courtesy of TSLA.)

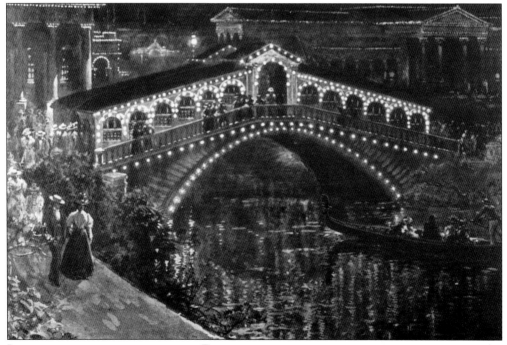

ILLUSTRATION SHOWING THE LIGHTED RIALTO BRIDGE AT NIGHT AND A COUPLE STROLLING ALONG THE EAST BANK OF LAKE WATAUGA. (Courtesy of TSLA.)

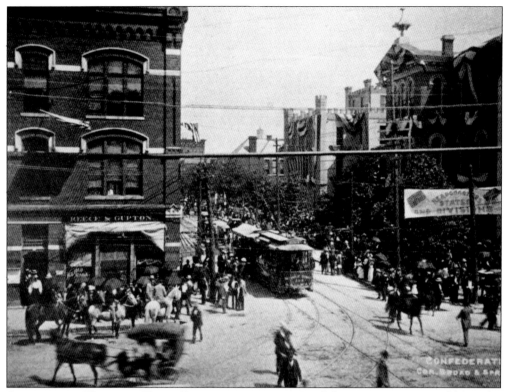

CONFEDERATE VETERANS DAYS, JUNE 22–24, 1897. Confederate veterans assemble at the corner of Broad and Spruce Streets for the grand parade on June 24th. Twenty-eight divisions marched in the parade, including Forrest's Cavalry, Terry's Texas Rangers, and the Survivors of Archers Brigade.

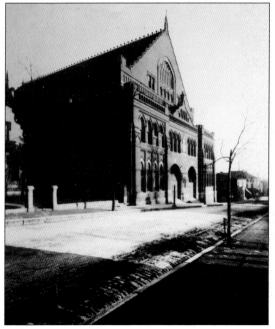

THE UNION GOSPEL TABERNACLE (RYMAN AUDITORIUM). Confederate veterans met here for business meetings, lectures, and special concerts. The Confederate Gallery was built to accommodate the old Confederates as they held their three-day annual reunion celebration. Rev. Sam Jones lectured there on Friday evening, June 6th. The occasion was the first opening of the gallery. (Courtesy of TSLA.)

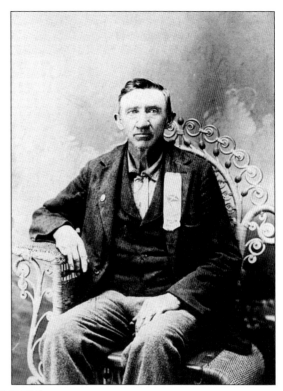

OLD CONFEDERATE VETERAN IN TOWN FOR THE REUNION (UNIDENTIFIED), WEARING SEVENTH ANNUAL REUNION RIBBON. Nashville welcomed the veterans with open arms. A reception hosted by the Nashville Daughters of the Confederacy was held at the state capitol on June 22 for the veterans. On June 23, a reception was held for Terry's Rangers at the Woman's Building. Others toured the Exposition grounds; the Cyclorama of Gettysburg was a favorite destination. (Courtesy of Herb Peck Jr.)

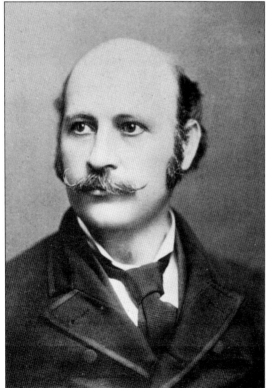

GOV. ROBERT LOVE TAYLOR. The governor welcomed the Confederate veterans to Nashville at the Tabernacle on June 22 with the greeting, "I'm glad I'm in Dixie!" which brought resounding cheers from the audiences. Governor Taylor participated in the closing ceremonies of the reunion on June 24. They were held at the Auditorium on the Centennial grounds where a great jubilee was held, and "Dixie" and the "Bonnie Blue Flag" were played over and over again. (Courtesy of TSLA.)

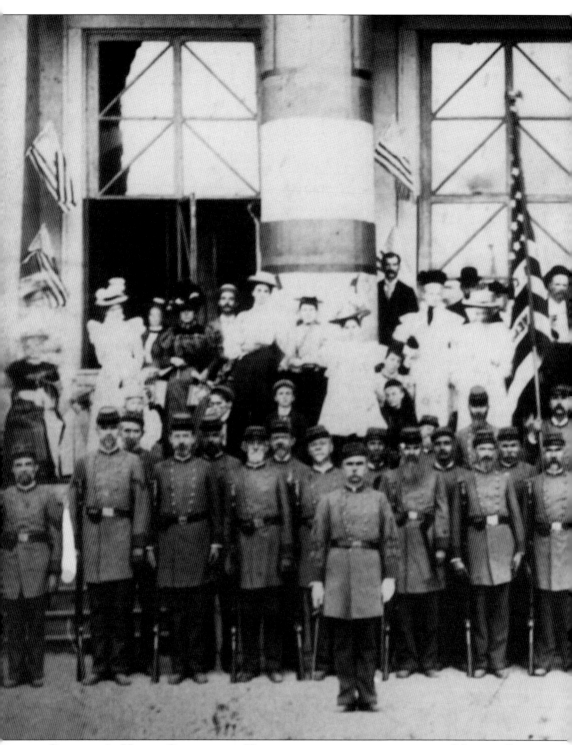

Company A, United Confederate Veterans pictured in front of the Memphis-Shelby County Building, the Memphis Pyramid. This occasion took place on September 14. Company A did a drill demonstration on the grounds in front of the Pyramid, as did another

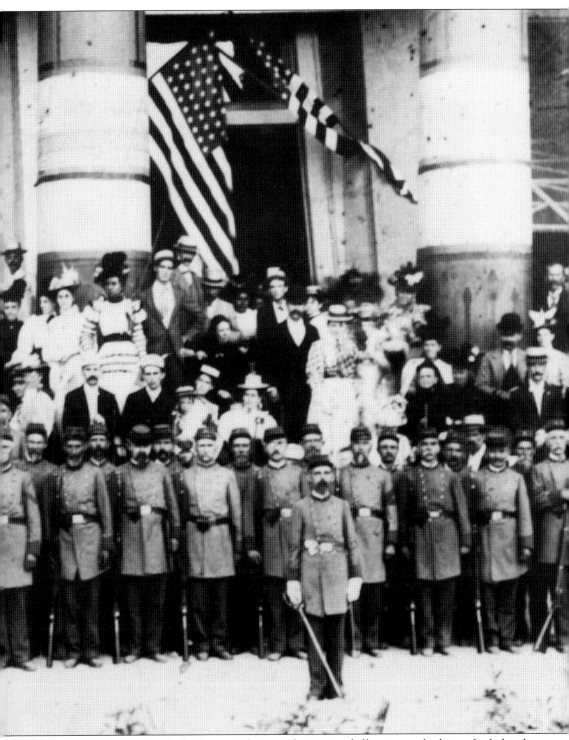
Memphis drill team, the Neely Zouves. This award-winning drill unit marched in order behind the executive committee in the veterans parade on June 24 and were wildly cheered by the crowds. (Courtesy of Steve McFarland and Alan Doyle.)

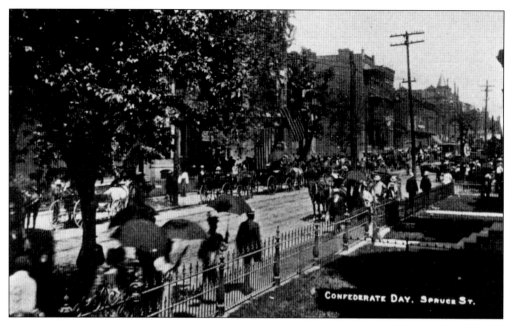

CONFEDERATE DAY PARADE, SPRUCE STREET, JUNE 24. Businesses provided ice water and lemonade along the parade route. The entire city was decorated in flags and bunting. Streets were lined with spectators cheering as the regimental bands played "Dixie." Black Confederate veterans, such as Scipio Africanus Cunningham of Mississippi and Louis Napolean Nelson of Ripley, Tennessee, also marched in the procession.

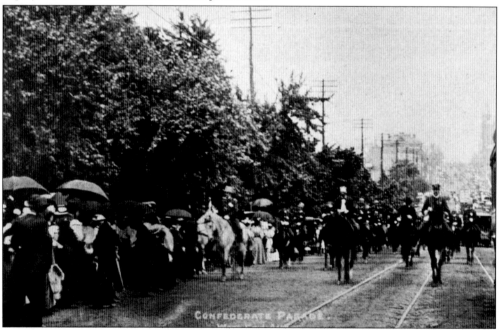

PARADE. As the parade route continued down West End Avenue, the old soldiers were reviewed from a stand by Gen. John B. Gordon of Georgia as they proceeded on to the Exposition grounds. Once at the grounds, they visited the Woman's Building, the History Building, the Cyclorama, and the Government Building, where relics of the war were on display.

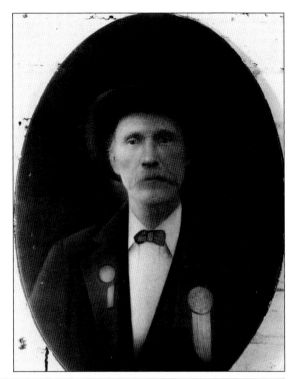

JAMES COLEMAN OAKLEY AT THE CONFEDERATE REUNION IN NASHVILLE. His granddaughter Minnie said that he was "stooped" and walked with a limp due to being in federal prison from 1863 to 1865. However, when she saw him marching, he was "stepping high with pride," and she jumped up and started yelling, "There is Pa! There is Pa!" (Courtesy of Mr. and Mrs. Edwin P'Poole.)

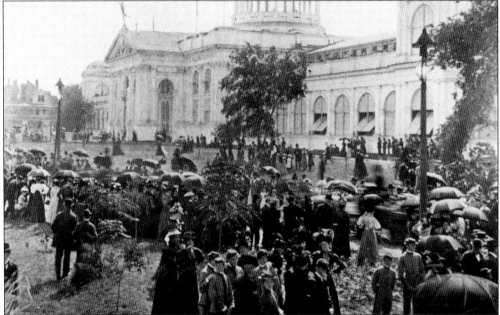

THE CROWD IN FRONT OF THE COMMERCE BUILDING ON NASHVILLE DAY, SEPTEMBER 11, WATCHES THE PARADE OF ALL OF THE VANITY FAIR ATTRACTIONS. At 10 a.m., orations by Mayor McCarthy and Governor Taylor were given in the Auditorium. At 3:30 p.m., the Conterno band performed a military and musical extravaganza entitled "Battle of the Nations" in the Auditorium. At 6:45 p.m., the Red Men gave a descriptive of an Indian attack on Nashville 100 years ago. At 8:30 p.m., a grand fireworks display was seen.

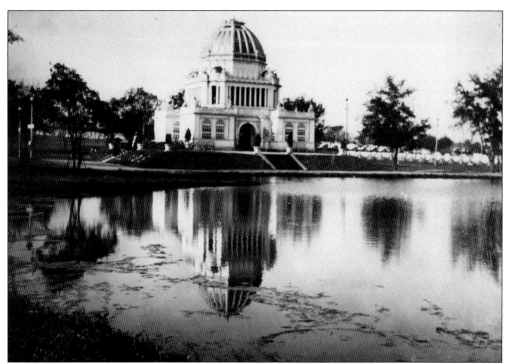

THE ILLINOIS BUILDING ON THE EAST BANK OF LAKE SEVIER. The encampment of U.S. troops drilled on the parade grounds in the afternoons and participated in five sham battles during the Exposition, two of which took place during military week, which was August 9–14. (Courtesy of TSLA.)

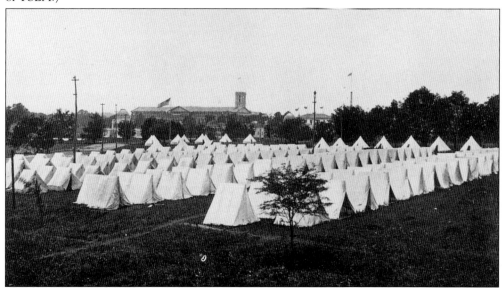

SOLDIERS IN CAMP. The military camp, which included U.S. infantry regiments, U.S. cavalry units, United States Colored Troops (U.S.C.T.) regiments, National Guard troops, and state militias, was in use from May through October. William Gerst provided meals for the troops in the soldiers' mess hall and the Cafe Militaire. Dances for the soldiers were often held in the nearby New York and Knoxville Buildings.

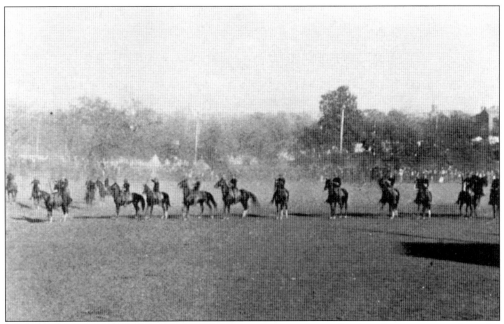

THE CAVALRY PARADE BEFORE THE SHAM BATTLE. August 12 was the day chosen to reproduce the Custer Massacre. The U.S. Cavalry troops attacked and were defeated by a large contingent of the Improved Order of Red Men, who played the part of the Indians in the battle.

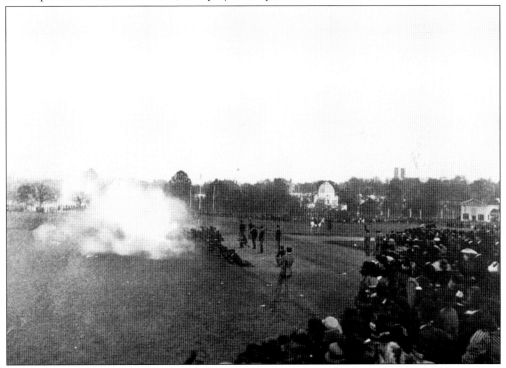

BEGINNING OF THE SHAM BATTLE, AUGUST 14. The first volley fired is shown here. The soldiers are kneeling or lying down and firing across Capital Avenue. Some of the state buildings can be seen in the distance.

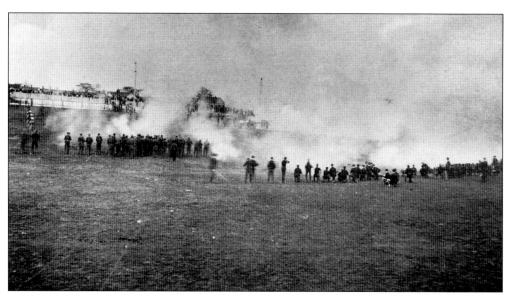

THE SHAM BATTLE. All of the sham battles were not up to required standards from a military point of view, but they delighted the public. Large crowds came to witness the maneuvers, especially during military week in August when the Battle of Little Big Horn was re-enacted. In the sham battle being conducted in the photograph, in the foreground, the Confederate veterans lead the way, as they often did in days gone by, when there was nothing "sham" about the battle.

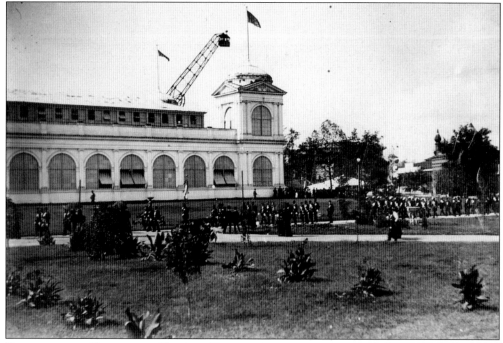

PARADE OF THE KNIGHTS ON TEMPLAR DAY AT THE NORTH END OF THE COMMERCE BUILDING. The Knights Templar, in uniform with their plumed hats, are marching from the left near the entrance to the Moorish Palace. The Giant See-Saw can be seen in the background. (Courtesy of TSLA.)

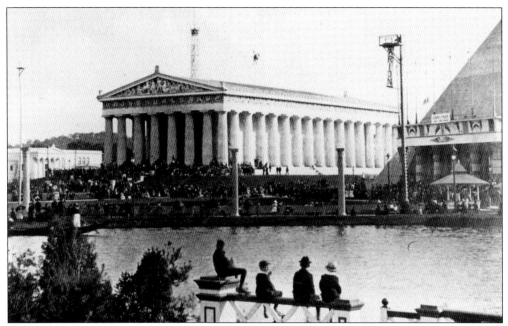

AN ACROBAT SHOW. The crowd is seated on the steps of the Parthenon, the Pyramid, and the banks of Lake Watauga, watching a rare daytime performance of the acrobat Arion. Arion would climb to the top of an 80-foot pole and walk across a live electrical wire holding a balancing pole. His usual performances were at night. The suit that he wore would emit sparks as he walked across the wire. Arion also rode a bicycle in his act. The year following the Exposition, Arion fell to his death, as he never used a net.

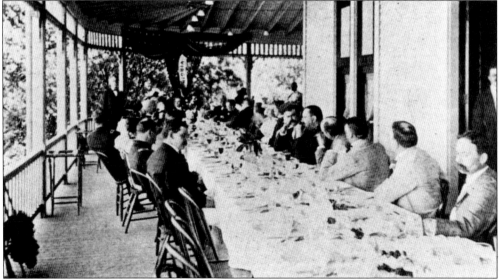

VIRGINIA DAYS, JUNE 16 AND 17. On the morning of June 17, the Fourth Regiment of Virginia troops arrived. A detachment of Centennial guards met the procession at the gate and led the way around the grounds while the regimental band played. Governor O'Ferrall reviewed the troops in front of the Commerce Building and attended a banquet at the West Side Clubhouse (above).

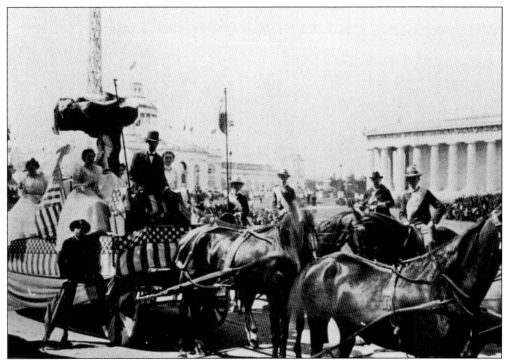

PATRIOTIC FLOAT IN PARADE ON SEPTEMBER 21, IRISH-AMERICAN DAY. The Parthenon (right) and Commerce Building (left) are in the background. Special days were celebrated by many other organizations. October 6 was German-American Day. September 21–23, were the Mexican War Veterans Days. September 23–28 was the National Spiritualists' Grand-Mass Convention, and October 1 was the Davy Crockett Clan Reunion.

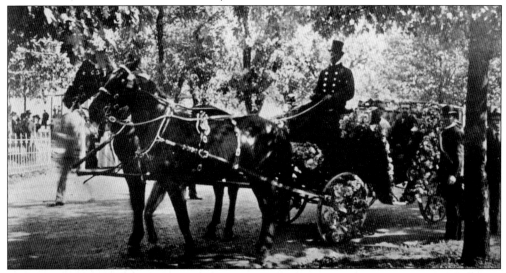

DIRECTOR GENERAL E.C. LEWIS'S DAY, OCTOBER 21, 1897. Major Lewis is pictured here in a decorated carriage with his aged mother as the parade is ready to commence. A parade of floats, thoroughbred horses, and cattle began at 11 a.m. and was followed by a pony show and races at 1 p.m. At 3:30 p.m., a great sham battle of Gettysburg, showing Pickett's charge, was staged. The evening ended with fireworks and a concert by the Bellstedt-Ballenberg Band.

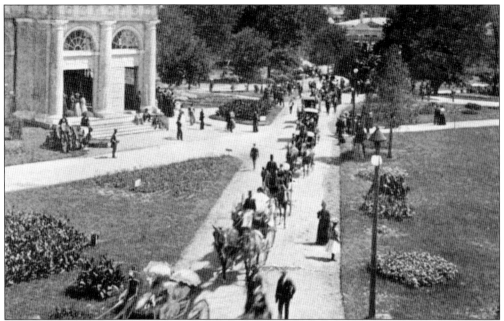

THE PARADE ON DIRECTOR-GENERAL'S DAY. This parade took place within the Exposition enclosure and was under the supervision of Grand Marshal R.T. Creighton. A large body of Centennial guards lead the procession. A line of Exposition officials was next, including Major Lewis, his wife and mother, and Major Thomas. They were followed by innumerable floats, bands of music, horses and ponies, and the Streets of Cairo people. (Courtesy of TSLA.)

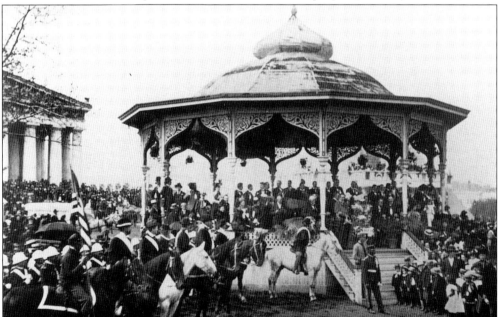

PRES. AND MRS. J.W. THOMAS REVIEWING THE PARADE FROM THE CENTENNIAL BANDSTAND. John W. Thomas Day had the greatest attendance of any day during the Exposition, with over 98,000 people going through the turnstiles. Gen. W.H. Jackson was the grand marshal of the parade, which took three hours to pass. Pres. and Mrs. Thomas arrived in a horseless carriage.

From the Giant Seesaw The forts and battlefields of Nashville can be seen.

Don't fail to see the attractions in Vanity Fair.

TUESDAY, OCTOBER 12.

Artists' and Authors' Convocation (Children's Building 11:00 A.M. to 1:00 P.M.).—New York State Day (11:00 A.M. to 1:00 P.M. in Auditorium, music by Fischer's Band).—Delaware Day.—Connecticut Day.—Fire Underwriters' Day.—Southern Conference Charities and Correction (12th to 14th).—Tri-State Medical Society, Alabama, Georgia, and Tennessee.—Nashville Sanitary Association (12th to 14th).—American Association Traveling Passenger Agents (12th to 15th).

PROGRAMME OF MUSIC—11:00 A.M.

11:00 A.M. to 1:00 P.M. Concert by Fischer's Centennial Orchestra in Auditorium.

PART FIRST.

1. March, Wien Berlin .. Schrammel
2. Overture. The Beautiful Galatea Suppe
3. Waltz, Tales from Vienna Woods Joh. Strauss
4. Two Hungarian Dances .. Brahms
5. American Patrol ... Macham

Battle of Gettysburg,
The Artistic Triumph of the 19th Century.

The Moorish Palace Caters to the Artistic and Cultured. A Pleasant Surprise awaits you here. The two immense floors are filled with Artistic Gems.

PART SECOND.

6. Indian War Dance ... Bellstedt
7. Waltz, Oak Hill ... Fischer
8. Patrol Comique ... Hindley
9. Selection from Herbert's Wizard of the Nile Clarke
10. Galop, Tallyho ... Bernstein

Beautiful Lake Watauga and the Venetian Gondolas, the most attractive resort.

Note Chimes in Auditorium at 10 a.m., 12 m., 6 p.m., and 7 p.m.

Cooking Made a Pleasure Is the Inevitable Result of a Trip Through **PHILLIPS & BUTTORFF'S,**
217, 219, 221 NORTH COLLEGE STREET.

(Side text: Ione the beautiful now on in Blue Grotto Theatre.)

OFFICIAL PROGRAMME LISTING THE VANITY FAIR ATTRACTIONS AS WELL AS THE CONCERT TO BE GIVEN BETWEEN 11 A.M. AND 1 P.M. BY GUSTAV FISCHER'S CENTENNIAL ORCHESTRA IN THE AUDITORIUM. (Courtesy of TSLA.)

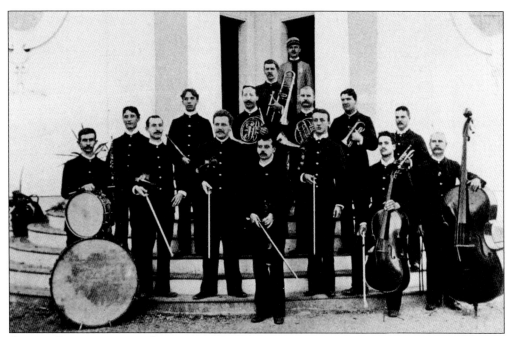

GUSTAV FISCHER AND HIS CENTENNIAL ORCHESTRA, WHO PLAYED ON NUMEROUS SPECIAL DAYS, ON THE STEPS OF THE AUDITORIUM. They also gave performances in the Woman's Building, the Parthenon, and at the Centennial Band Stand. Popular music of the day included the Sousa marches, and they were played on every occasion.

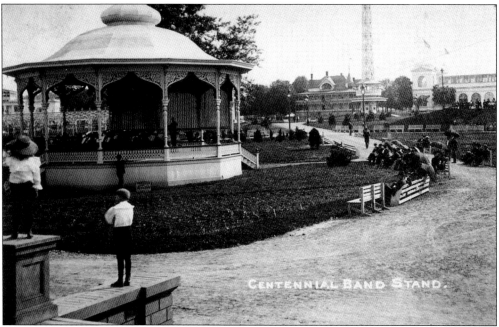

BOYS ON THE STEPS OF THE RIALTO LISTENING TO THE MUSIC OF THE FISCHER BAND. Several of the bandmasters who came to Nashville with their bands wrote special pieces of music for the Exposition. Bellstedt wrote the "Director General's March," Innes wrote the "Belle of Nashville," and Conterno wrote "The Fair Nashvillian." (Courtesy of Edwin and Evelyn P'Poole.)

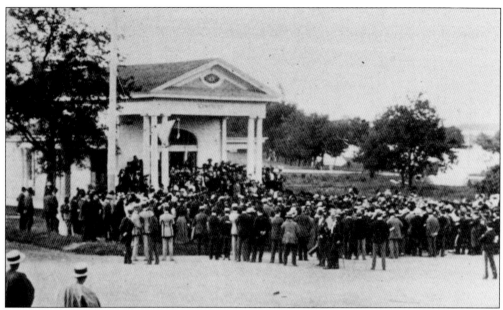

CROWDS GATHERED AROUND THE FRONT PORCH OF THE KENTUCKY BUILDING ON KENTUCKY DAY, MAY 24. Gov. W.O. Bradley gave a speech, and Miss Elsie Yandell then sang "My Old Kentucky Home," with the members of the Louisville Legion joining in on the chorus.

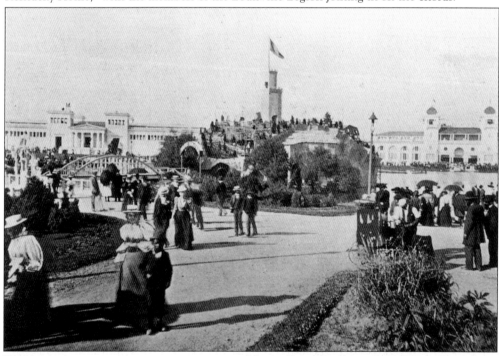

THE OFFICIAL DEDICATION AND OPENING OF THE NEGRO BUILDING (RIGHT) ON NEGRO DAY, JUNE 5. Orations were given by Mr. Richard Hill, Maj. J.W. Thomas, and Mr. Charles Anderson of New York. A few of the many days that honored African Americans were Fisk University Day, June 12; Emancipation Day, September 22; Negro Preachers' Day, October 16; and Fisk Jubilee Day, October 6.

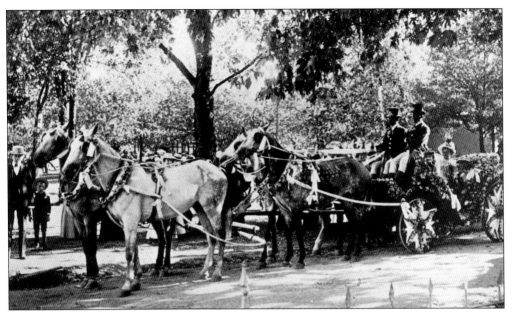

MRS. VAN LEER (KATE) KIRKMAN IN A BEAUTIFULLY DECORATED CARRIAGE ON KATE KIRKMAN DAY, SEPTEMBER 30. Mrs. Van Leer Kirkman was the chairman of the Woman's Department, and she was honored with a Flower Parade. Her son Wayne is seated by her side.

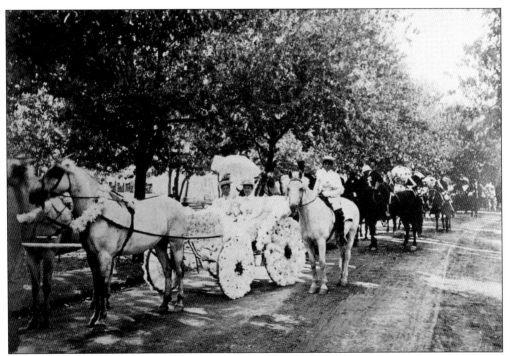

THE FLOWER PARADE WAITING TO BEGIN. The first vehicle is a trap decorated in white chrysanthemums belonging to Mrs. J.R. Hunter Orr. Mrs. Orr and Mrs. Brooks are seated in the trap.

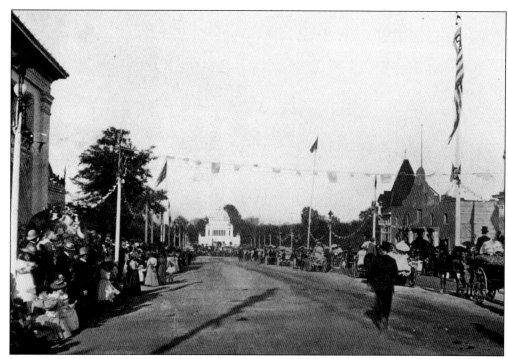

THE FLORAL PARADE PICTURED GOING DOWN CAPITAL AVENUE. The Illinois Building is situated in the center, and the Texas Building is to the right.

MRS. FELIX EWING AND HER STYLISH VICTORIA IN THE FLORAL PARADE. The victoria was made to resemble an immense green basket on to which great pink chrysanthemums were added for decorative effect. Mrs. S.A. Champion also occupied a seat in the victoria. This victoria was drawn by two splendid bangtail chestnuts and took the prize as the prettiest of the ladies' carriages. The prize was a silver loving cup.

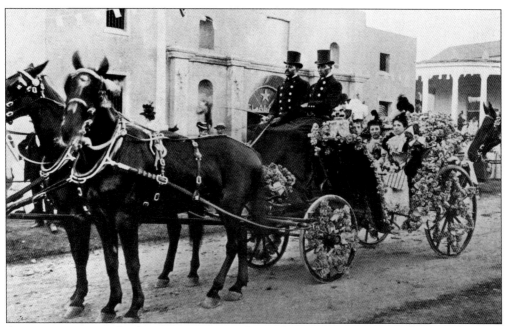

ANOTHER VICTORIA. In this victoria, trimmed in yellow roses and blue violets, rode Mrs. B.F. Wilson; Mrs. John Garneau, of St. Louis; and Mrs. John M. Gray Jr. The picture was taken in front of the Alamo.

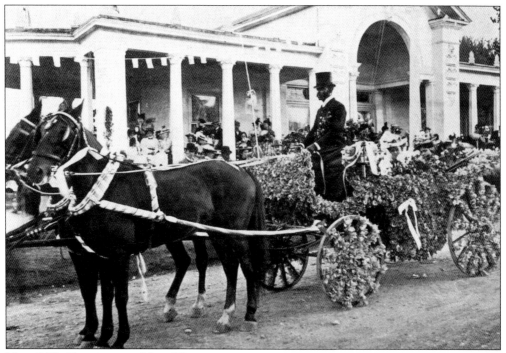

MRS. J.W. THOMAS AND MRS. WASHINGTON, ALMOST HIDDEN IN A MASS OF BRIGHT FLOWERS. The picture was taken in front of the Cincinnati Building.

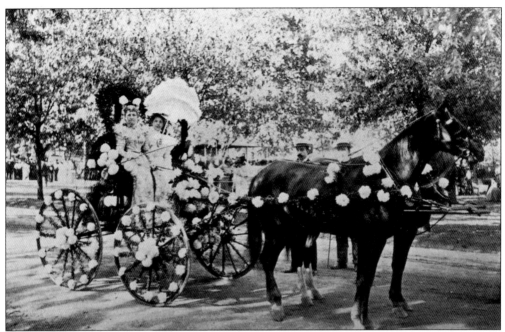

HANDSOME TRAP. In this vehicle rode Mrs. Thomas B. Neal, of Atlanta, and Mrs. Abram Tillman. The trap was wrapped in hundreds of yards of similax and was decorated with masses of snowballs.

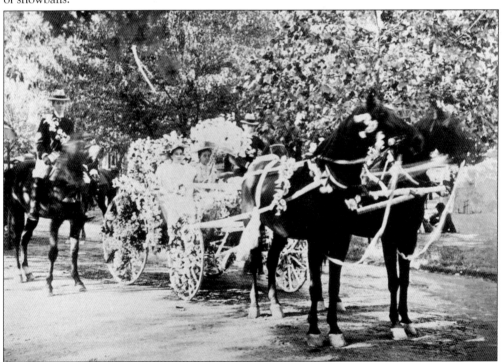

PHAETON. One of the most admired rigs in the floral parade was this phaeton, framed in pink and blue morning glories. Its passengers were Miss Sammie Keith and Miss Louise McClure. Their escort was composed of Mr. Johnson Bransford and Mr. Carter Reeves.

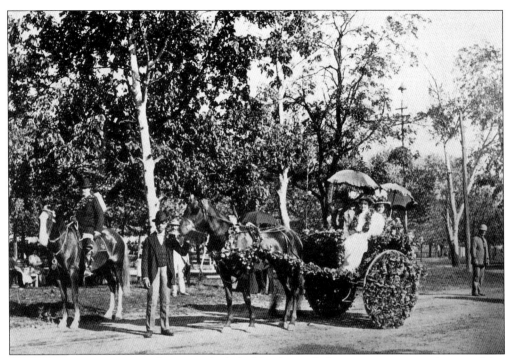

A BOUQUET OF LOVELINESS. In a trap fairly hidden beneath Japanese poppies and ivy sat Miss Margaret Shook, Miss Grey McLaughlin, Miss Sadie Griffin, and Miss Elizabeth Howell. Their escorts were Dr. Thomas Weaver and Mr. Robin Jones.

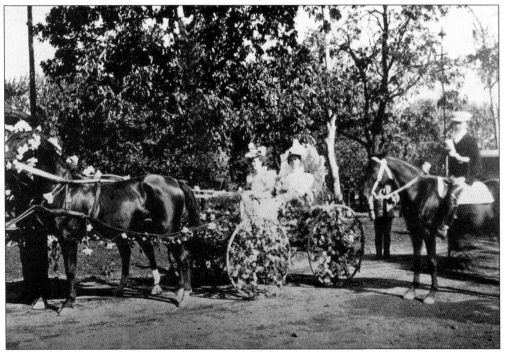

PINK AND WHITE TRAP. Miss Medora McAlister and Miss Idella Sawrie rode in a trap trimmed in pink roses, under a sunshade of white and pink blossoms.

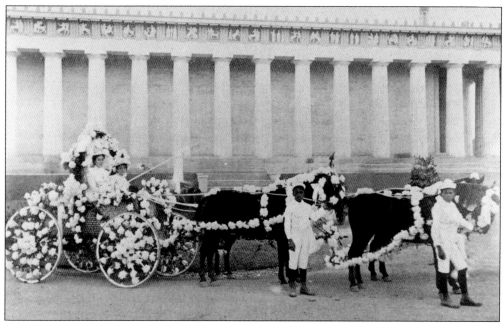

PRIZE-WINNING TRAP. This trap took the prize, a beautiful chatelaine, offered for the most artistic of the young ladies' traps. Miss Mary Bass, Miss Tyllye Porter, Miss Leonora O'Bryan, and Miss Rebecca Porter were in the turnout shown above, which presented a great basket of straw with masses of white peonies.

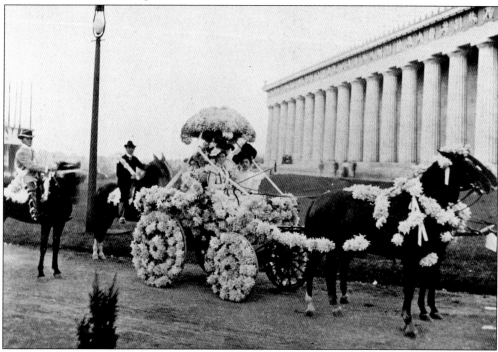

ANOTHER ENTRY. In a yellow cart, decorated in blue Japanese chrysanthemums, were Miss Nannie Dudley Pilcher, of Nashville; Miss Brown, of Chicago; Miss Anna Gay, of Louisville; and Miss Burnett, of Kentucky. Mssrs. John McFerrin and Merritt Pilcher acted as escorts.

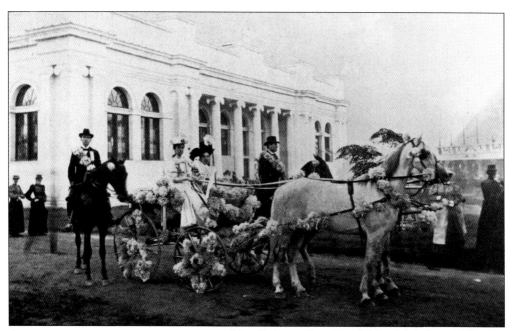

ANOTHER ENTRY IN THE FLOWER PARADE. Miss Roberta Sewell and Miss Mary Laura Champe were in a rig bedecked with pink chrysanthemums on a golden background and drawn by two splendid white horses. Their escorts were L.C. Garrabrant and John Early. The Education and Hygiene Building is seen in the background.

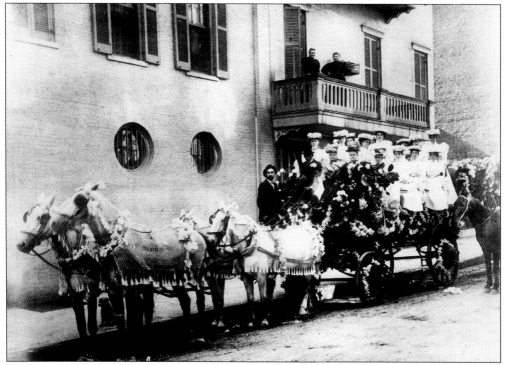

AN UNIDENTIFIED GROUP OF YOUNG LADIES ON KATE KIRKMAN DAY, SEPTEMBER 30. (Courtesy of TSLA.)

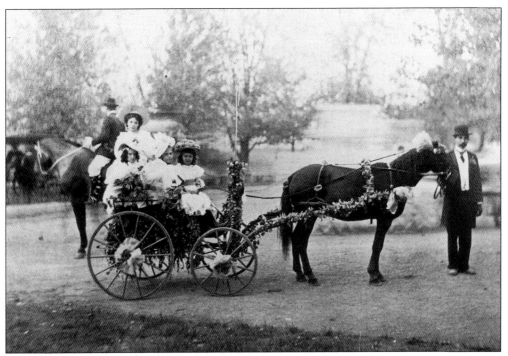

A PONY CART WITH FOUR LITTLE BEAUTIES. Miss Mildred Buford had with her in this turnout, little Misses Margaret Fall, Elizabeth Dallas, and Lena Cummins. The cart was decorated beautifully in yellow roses and smilax, and the pony wore yellow ribbons on his mane.

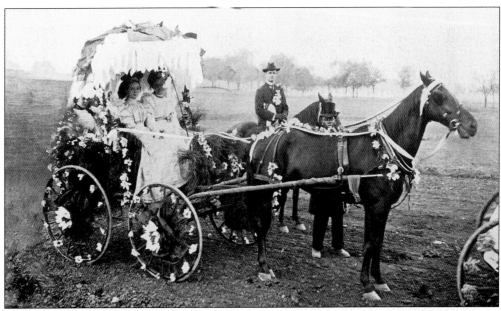

WATER LILY CARRIAGE. Miss Anna Walker Edwards; Miss Louise Todd, of Atlanta; Miss Anna Lewis; and Miss Minnie Bond rode in Miss Edwards's carriage, which was covered with water lilies. Their escorts were: Colonel Stewart, of Cleveland; Mr. Dacy, of Boston; Mr. Brown, of South Carolina; and Mr. Granville Sevier.

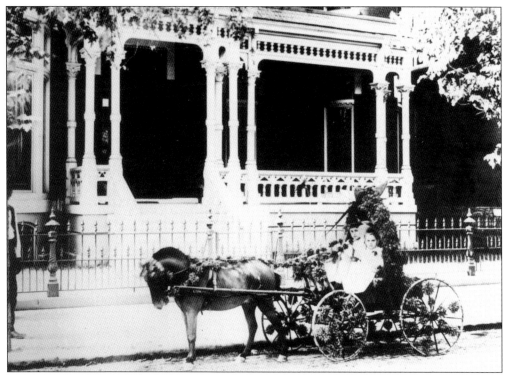

PRIZE-WINNER. A pretty little cart, drawn by a pony and decorated as a bed of yellow roses, contained little Misses Margaret and Mary Tom Warner. This picture was taken just as the cart was leaving the children's home. This vehicle took the prize as the prettiest of the children's pony carts in the parade.

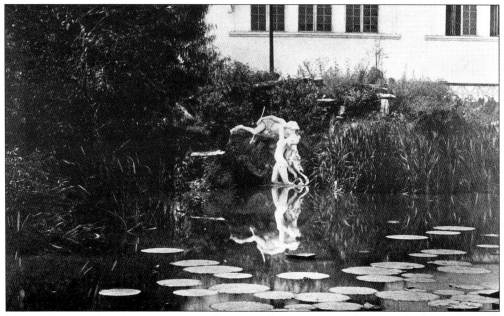

THE GROTTO IN LILY LAKE WITH THE SHEPHERD BOY AND THE MERMAID. In the foreground, water lilies cover the surface of the water. The Transportation Building is in the background.

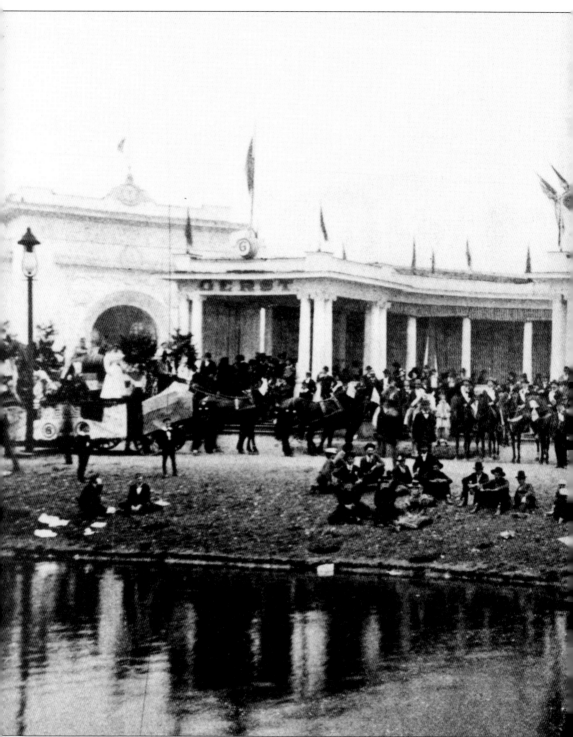

THE WILLIAM GERST BREWING COMPANY'S DISPLAY. There were many notable private turnouts in the great parade of Thomas Day, and here is one shown above. The William Gerst Brewing Company had beautiful floats and mounted their employees on horseback, making up a long

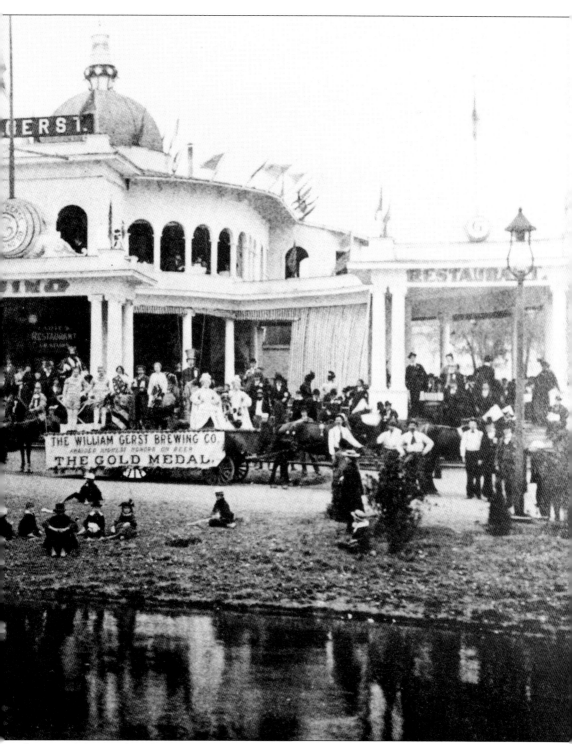

division of the parade. This picture shows the front of the Casino. The sashes and equipment, the fine horses, the beautiful floats, and the charmingly costumed girls were all representative of many other parts of the great procession.

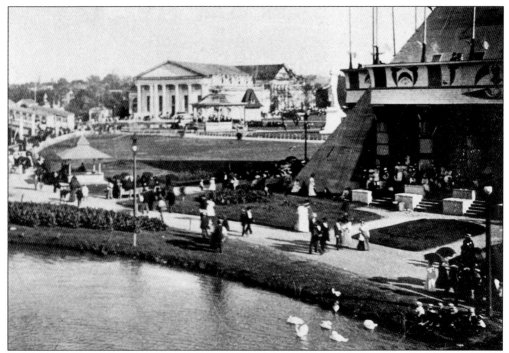

FAIRGOERS ALONG THE WEST BANK OF LAKE WATAUGA. Young boys have fun with the ducks (lower right). The Memphis Pyramid is situated to the right, and the Minerals and Forestry Building is in the background.

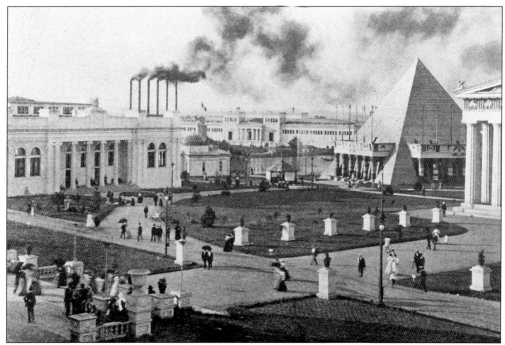

VIEW FROM THE TOP OF THE COMMERCE BUILDING. The Education Building is to the left, and the Pyramid and the Parthenon are to the right.

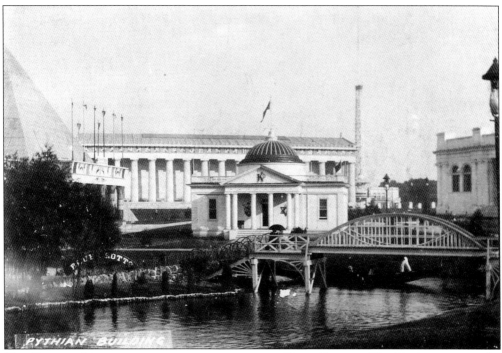

THE PYTHIAN BUILDING AT THE ENTRANCE TO THE BLUE GROTTO. The Parthenon is in the background. (Courtesy of TSLA.)

CLOSING DOWN. Crowds walk toward the exits at the main entrance gates, as the end of the Tennessee Centennial Exposition draws near. The great celebration closed its gates for the final time after the fireworks display on Saturday evening, October 30.

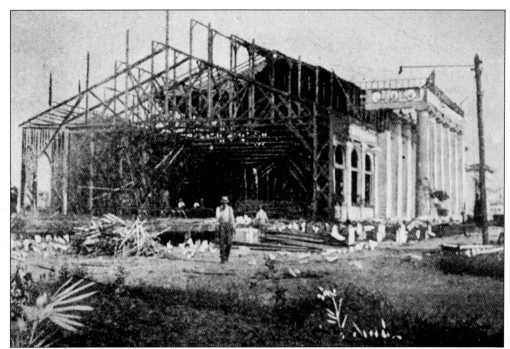

THE MINERALS AND FORESTRY BUILDING. At the end of the six-month-long celebration of Tennessee's 100th year of statehood, most of the buildings on the grounds were torn down or moved to other locations. Only a handful remained by the end of 1898. Most suffered the fate of the Minerals and Forestry Building pictured here. They were torn down and sold for their lumber or moved to other locations. The Parthenon is the only surviving structure on the grounds. (Courtesy of TSLA.)

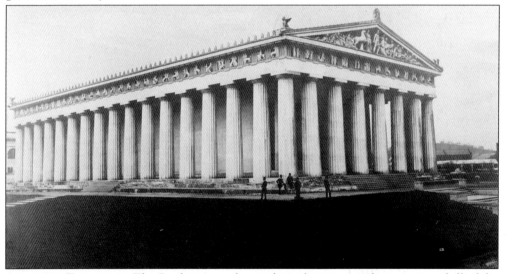

AFTER THE EXPOSITION. The Parthenon, today, is the only structure that remains of all of the magnificent buildings that once graced the Centennial grounds. This photo shows the barren Exposition grounds with only the Commerce Building in view behind the Parthenon. The Nashville Building was reconstructed in the 1920s and became a permanent structure. Today, it still stands as the "Crown Jewel" of Centennial Park. (Courtesy of Peggy Dillard.)